QUEEN FROM NO SCENE

Queen from No Scene
Published in Great Britain in 2024 by Graffeg.

ISBN 9781802586909

Written by Billie Charity and Dean Goodwin-Evans copyright © 2024. Photography by Billie Charity copyright © 2024. Designed and produced by Graffeg Limited copyright © 2024.

Graffeg Limited, 24 Stradey Park Business Centre, Mwrwg Road, Llangennech, Llanelli, Carmarthenshire, SA14 8YP, Wales, UK. www.graffeg.com.

Billie Charity and Dean Goodwin-Evans are hereby identified as the authors of this work in accordance with section 77 of the Copyright, Designs and Patents Act 1988.

A CIP Catalogue record for this book is available from the British Library.

All rights reserved. No part of this publication may be reproduced, stored in a retrieval system or transmitted, in any form or by any means, electronic, mechanical, photocopying, recording or otherwise, without the prior permission of the publishers.

The publisher gratefully acknowledges the financial support of this book by the Books Council of Wales. www.gwales.com.

1 2 3 4 5 6 7 8 9

MIX
Paper from responsible sources
FSC® C014138

QUEEN FROM NO SCENE

Billie Charity & Dean Goodwin-Evans

Queen from No Scene

On an Eardisley farm in conservative, rural Herefordshire lives Dean Goodwin-Evans aka Boo La Croux: farmer, organiser of Hereford Pride, professional hairdresser, son of an Aston Villa footballer, husband of Paul, lover of horses and Miss Drag UK 2021.

This man, in all his multi-coloured glory, is a photographer's dream. He looks incredible in full drag, and in combination with the animals on his farm, the visuals are spectacular.

I first met Dean at Hay Pride in June 2022. I had never given drag queens much thought before. I had not really had any reason to consider why a man would want to dress up as a woman. But as I got to know Dean, he became increasingly fascinating. He is incredibly open about his background and his life, such as a childhood spent with an unconventional father, ejected from Aston Villa for punching a referee, and whose criminal activities led to petrol bombs being thrown through Dean's kitchen window when he was a kid.

He told me how, when he wasn't dodging petrol bombs, he spent his early years thinking he was a girl, under the repressive shadow of Section 28 – the vile Tory legislation which made it illegal for schools to mention homosexuality. I was at school when Section 28 was brought in and it just wasn't even a thing for me and my friends. Looking back, there must have been others like Dean who were being made pointlessly miserable and ashamed, forced to hide their true identities, experiencing all the downsides superheroes face, but without the world-saving antics to make up for it.

Things changed at the age of 16, when Dean met a man in a gay bar in Leicester – he no longer felt like a girl, but for the first time felt like a gay man. His dad found out and gave Dean a beating, maybe like the one he'd given that football referee years before.

This man, in all his multi-coloured glory, is a photographer's dream.

I started designing and creating
outfits during lockdown and taught
myself how to sew. It's been so
natural and has become a real
therapy for me. This is a sketch of
the front cover costume.

Watching
Dean become
Boo is such
a privilege,
knowing that
all his outfits
are handmade
by him.

Dean climbed out of his bedroom window and lived on friends' sofas until he found an LGBTQ+ centre in Leicester, which looked after him and found him somewhere to live. Dean's dad later became his biggest supporter, before he passed away in 2009.

Boo La Croux started to emerge while Dean was watching early USA episodes of *Ru Paul's Drag Race*. Dean spent a year perfecting his look, unknown even to Paul, discovering what worked and what didn't, before he was ready to introduce her to the world. Fairly soon, in 2021, he was crowned Miss Drag UK.

Watching Dean become Boo is such a privilege, knowing that all his outfits are handmade by him. His eyes are different colours, green for Dean, blue for Boo, and his hair is immaculate in every incarnation, his professional hairdressing skills on clear display. The transformation is incredible, his beauty jarring against the agricultural backdrop.

As Boo La Croux, Dean calls himself the Queen from No Scene. But who knows how many more farmers are experimenting with their identities in potato barns around the county? How many people are hiding their true selves, for whatever political, religious or family reasons? Maybe there really is a scene in Herefordshire, it's just that it's mostly invisible at the moment. I look at Dean, and at the new generation, and it gives me a lot of hope that it will soon become normal for people to express themselves however they like.

In the meantime, in all her glory, here is Boo La Croux.

Billie Charity

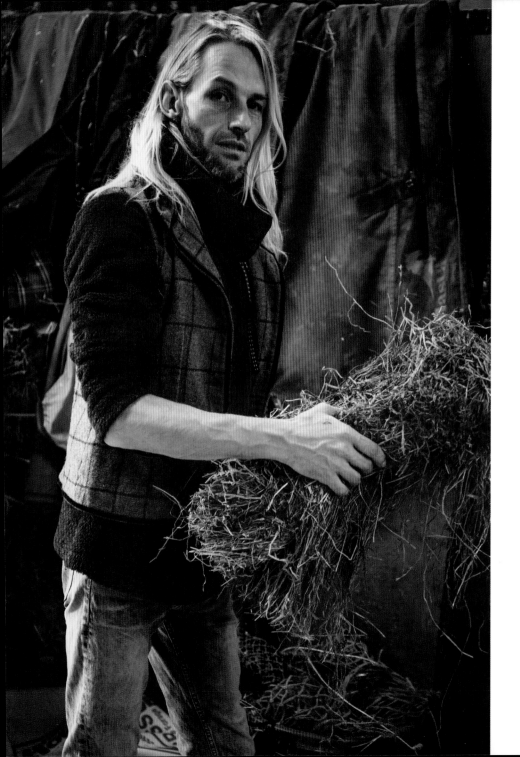

I believe I am
the only farmer
drag queen in
the world.

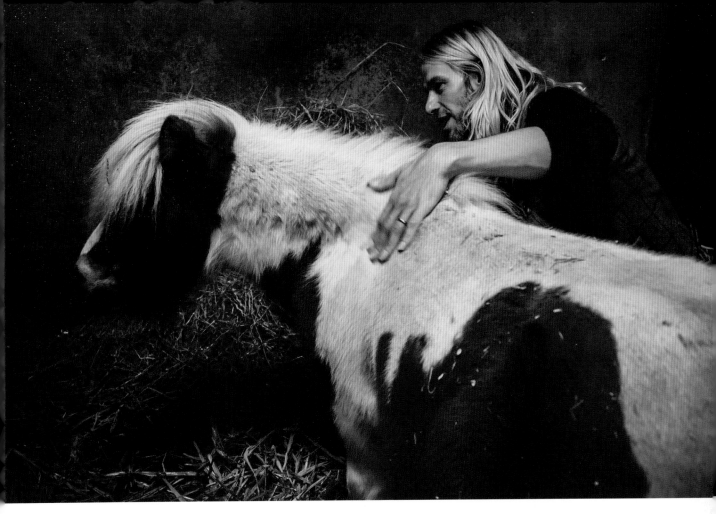

Being on a farm isn't a job,
it's a way of life.

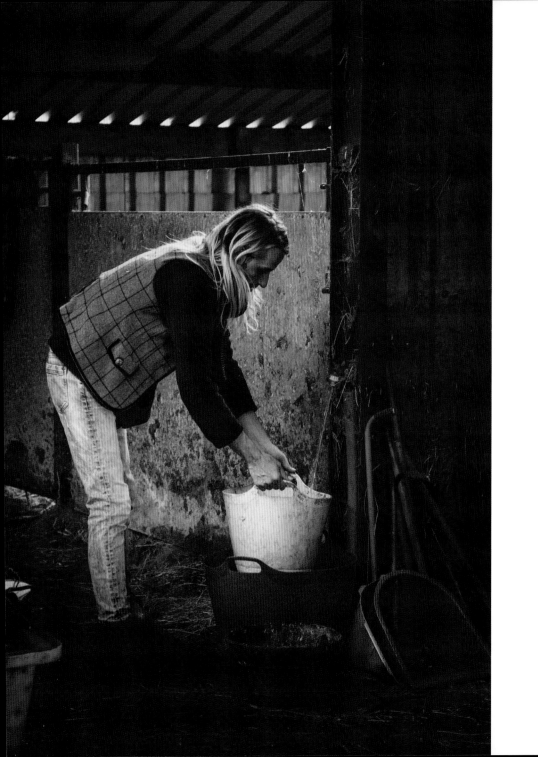

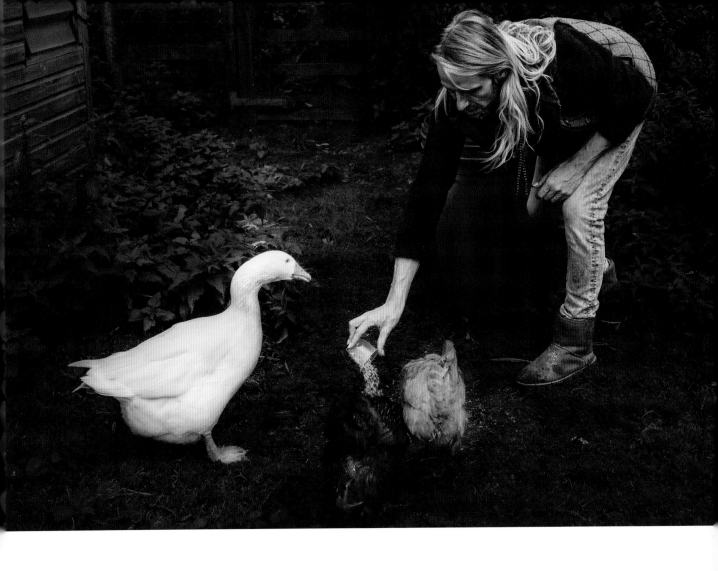

My animals are my friends.
They ask no questions and
pass no criticism.

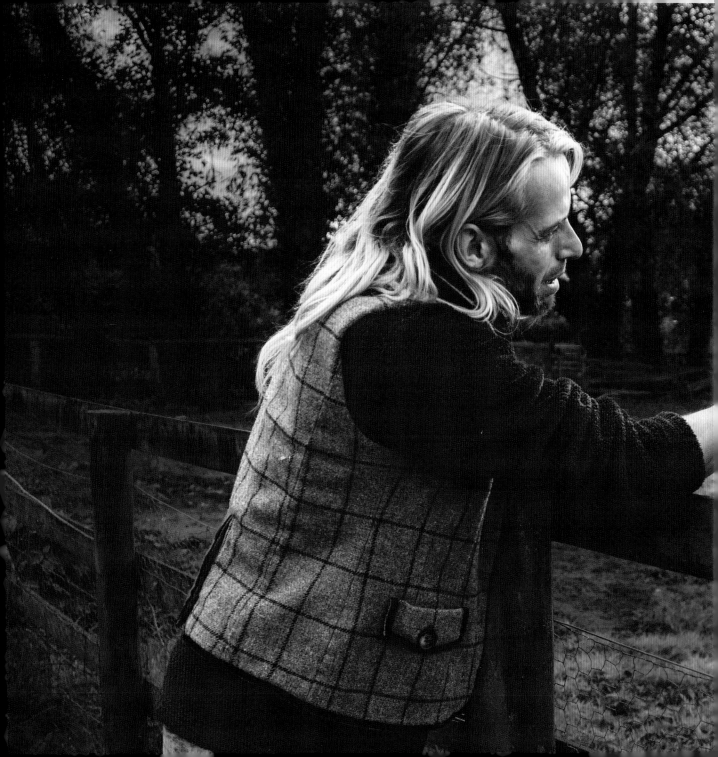

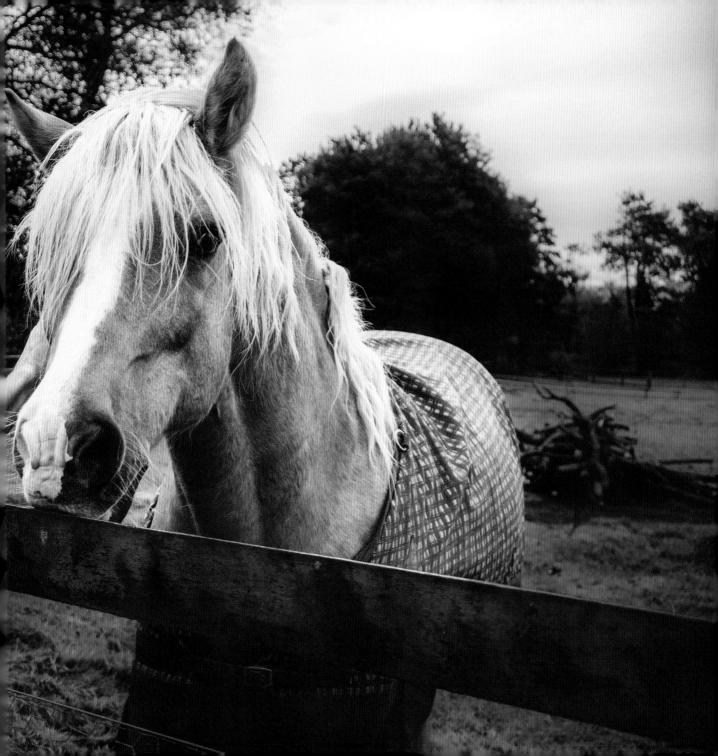

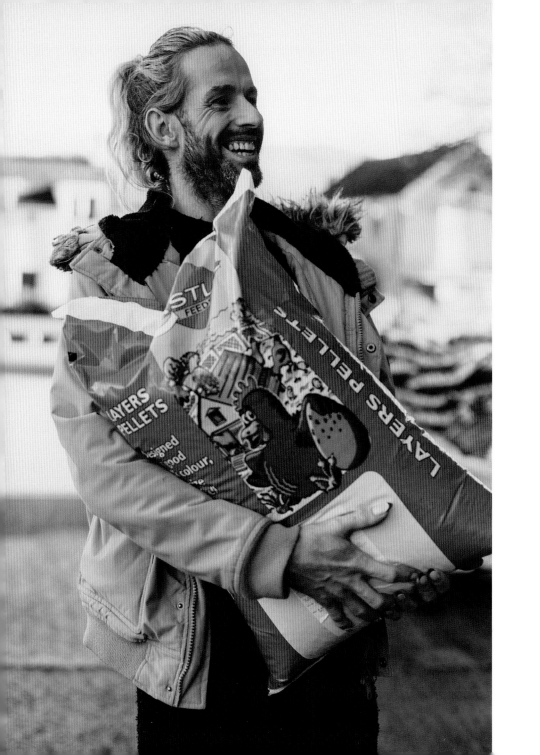

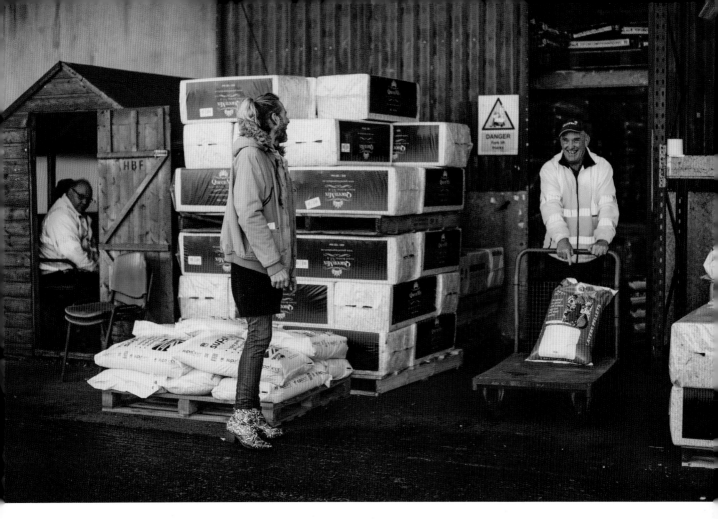

Support from local farmers and suppliers has been invaluable to my success as a farm owner and local drag artist.

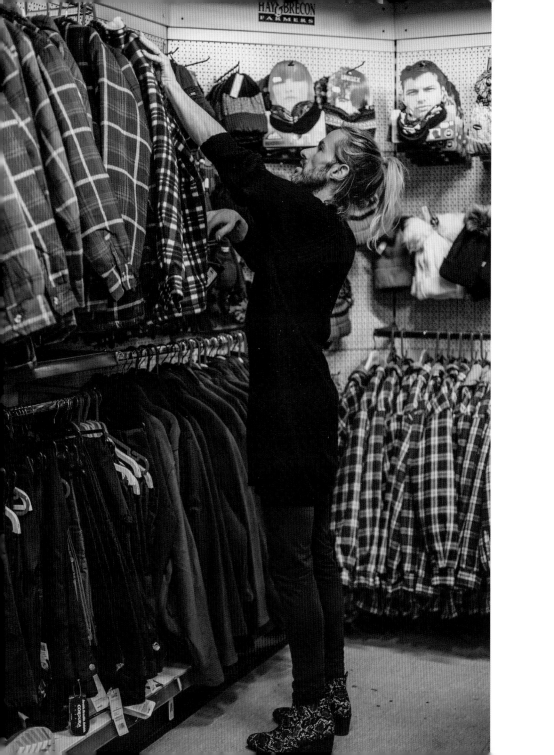

Our animals are like our children. Animals have always been a huge part of my life, from when I was very young and my grandparents were pig farmers. They also had horse-drawn ice-cream carts.

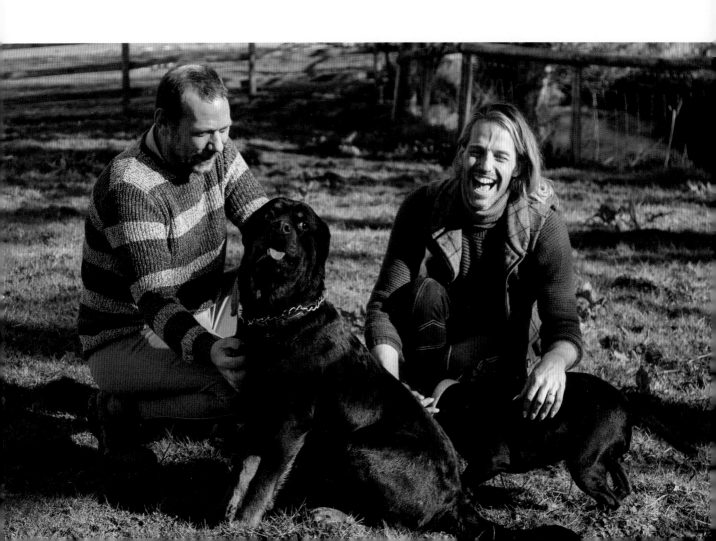

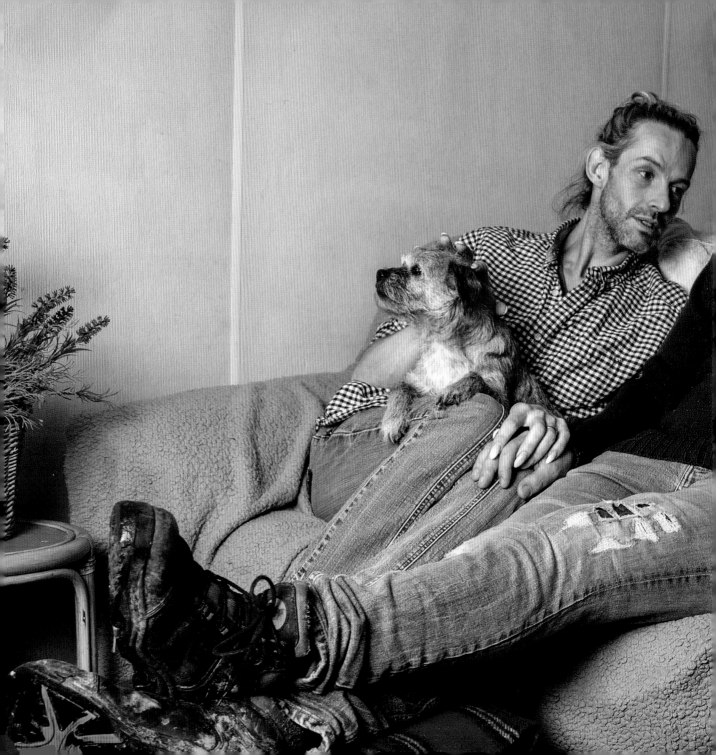

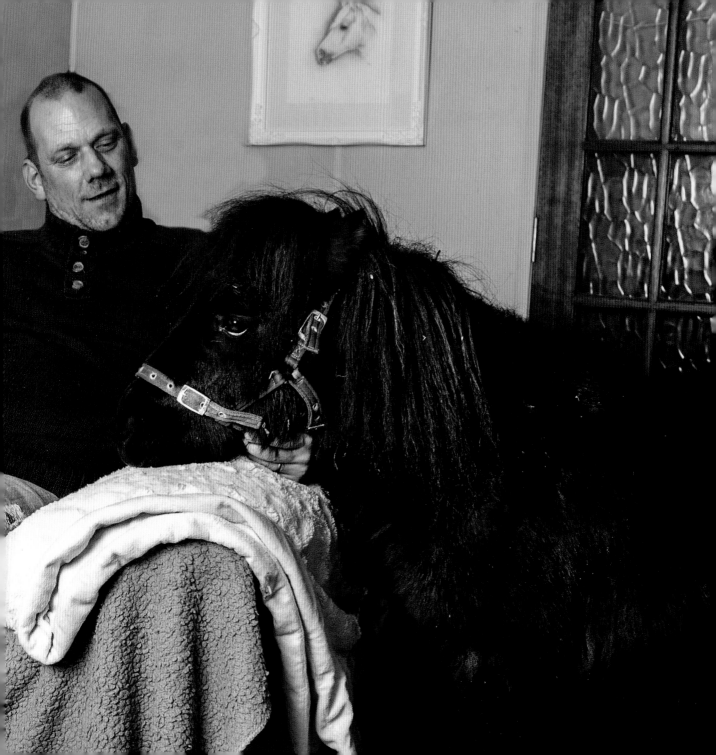

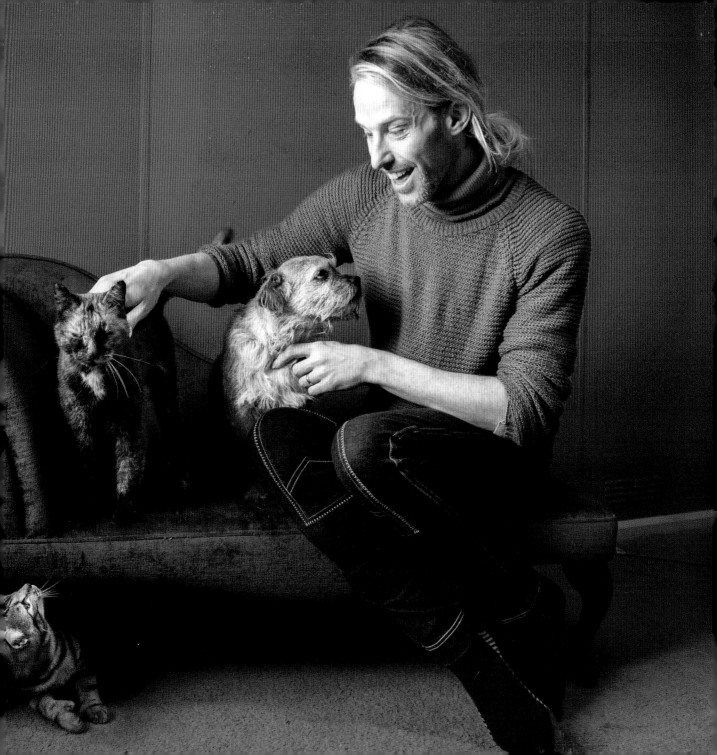

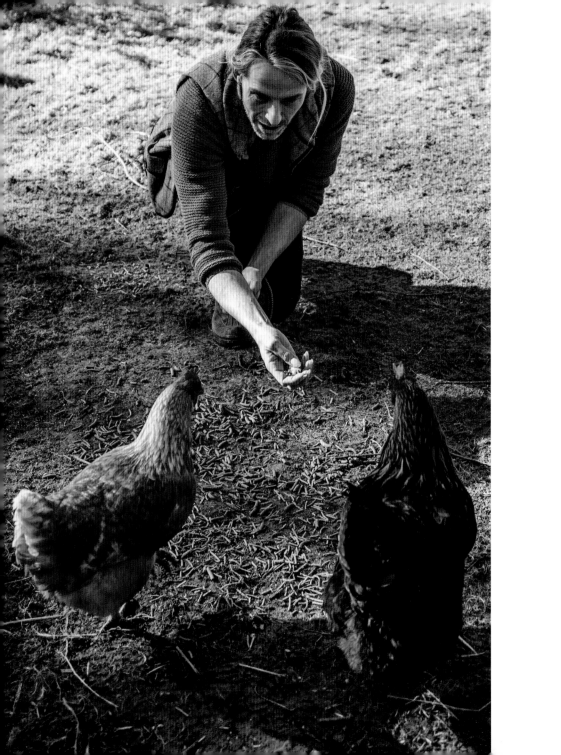

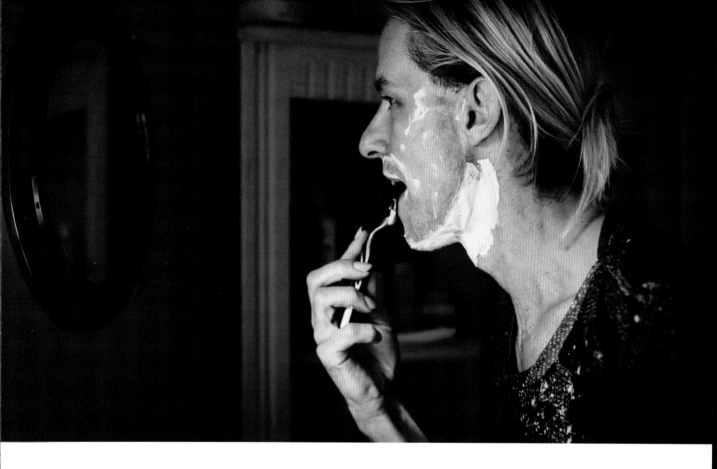

You've really only got yourself in life,
and if you don't make yourself happy,
someone else isn't going to.

Contact lenses help me achieve
'Boo's blue'. This is one of the most
important aspects of my art, and
I don't feel like I'm in drag until
I have my blue contacts in.

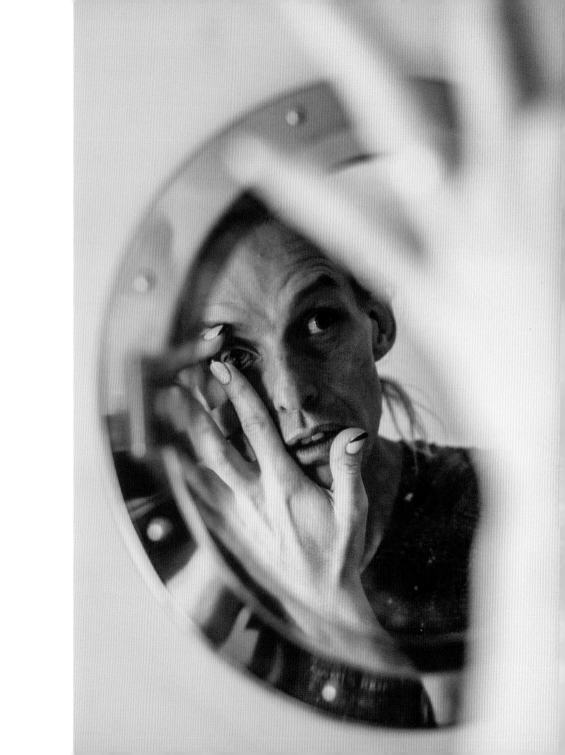

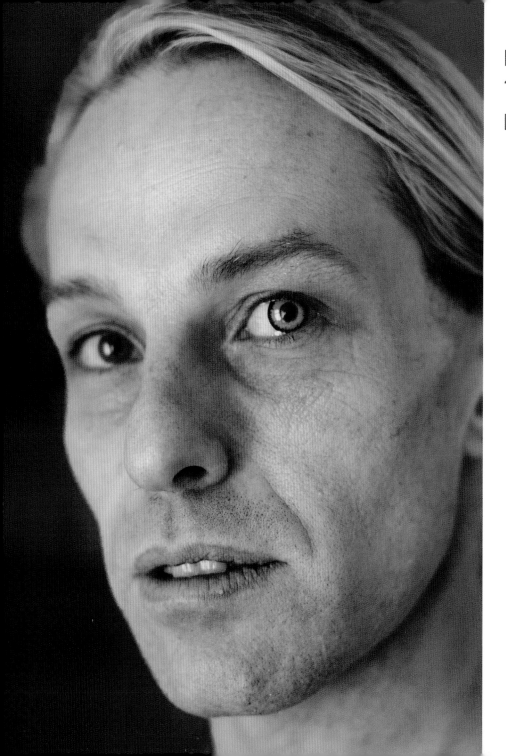

I always say,
'Boo's blue,
Dean's green.'

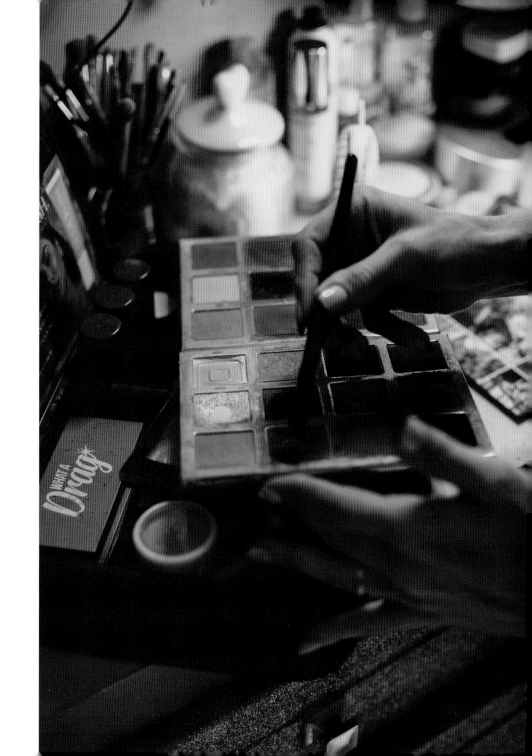

I practised alone for a year, perfecting my look and contemplating people's reaction to my new hobby.

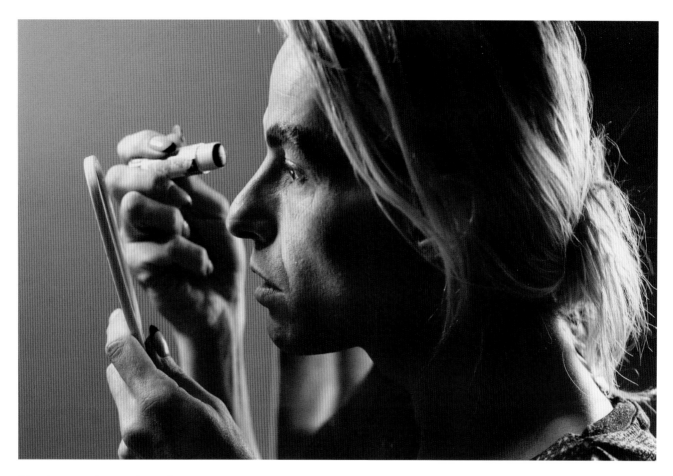

Simple everyday products like
glue sticks help me transform
into my expression of femininity,
removing the boy by gluing my
eyebrows and hairline down.
The glue lays down my own brow
to help me create a new 'drag'
brow. This purple glue dries clear,
which is why drag artists use it.

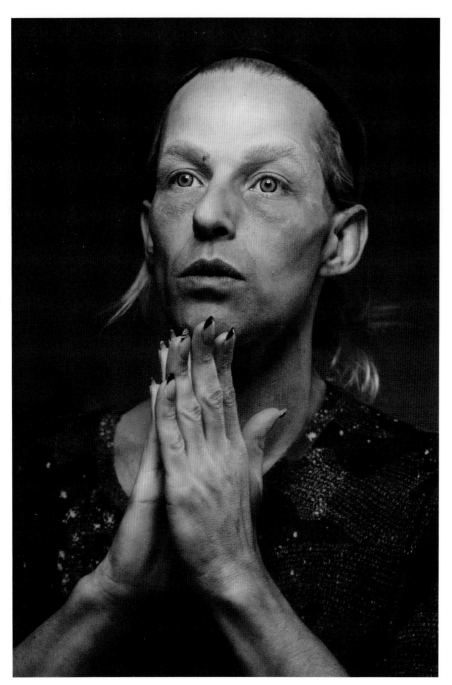

As a drag artist, I have had to learn techniques on how to paint feminine shapes with make-up to achieve my drag looks. Contouring and highlighting is used to achieve a more delicate look, making my nose look smaller, highlighting cheekbones and enhancing lips, techniques that women now use to achieve a more feminine look with their own make-up. Drag has been a leader of make-up techniques for decades.

The hairdryer helps me accelerate
the drying process of the glue.

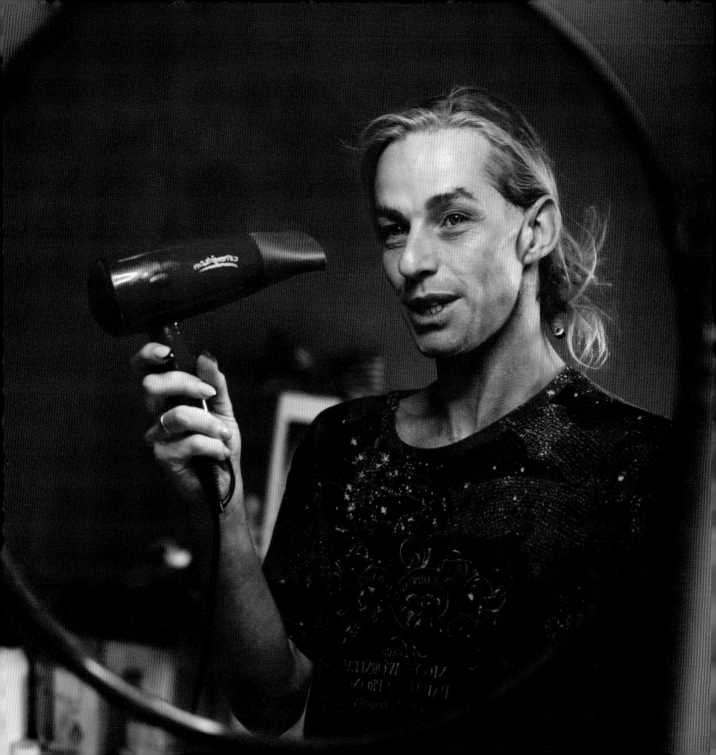

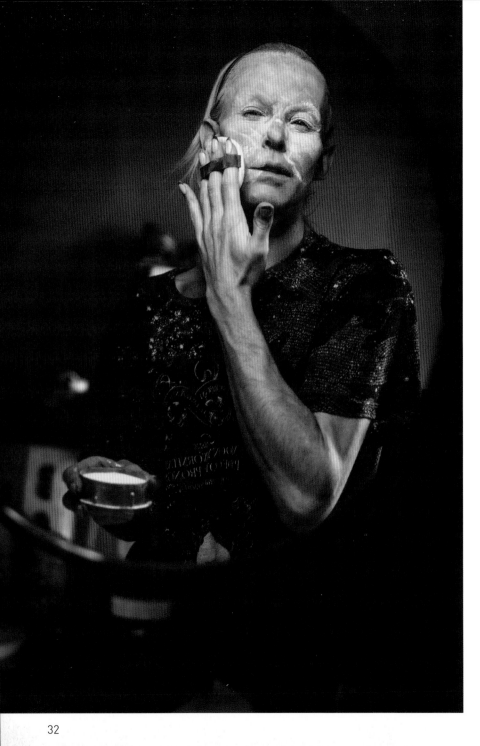

I use powders and sprays to set
my look in place to last the night,
otherwise the make-up would
slip off the face.

In drag culture we call this 'beating the face', which beats the powder into the face to achieve the smoothest look possible.

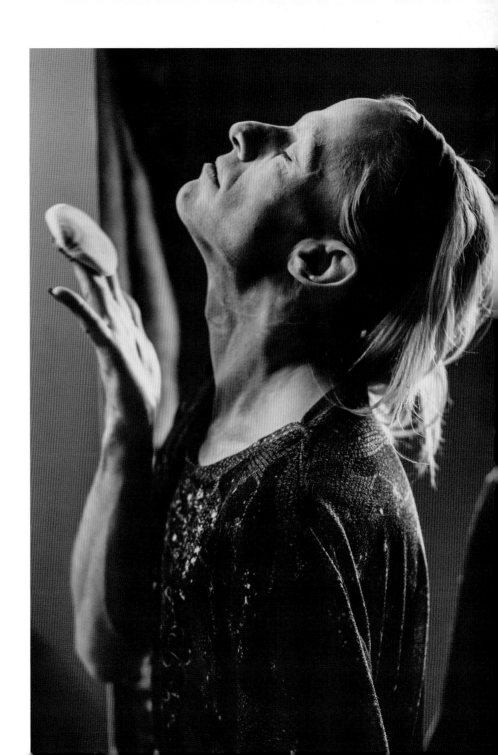

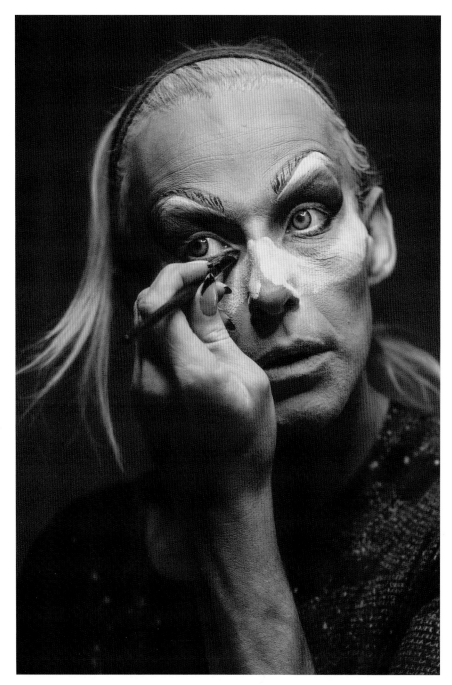

I add powder under the eyes for safety while applying my eye shadow, as this catches the fall and then can be easily brushed away.

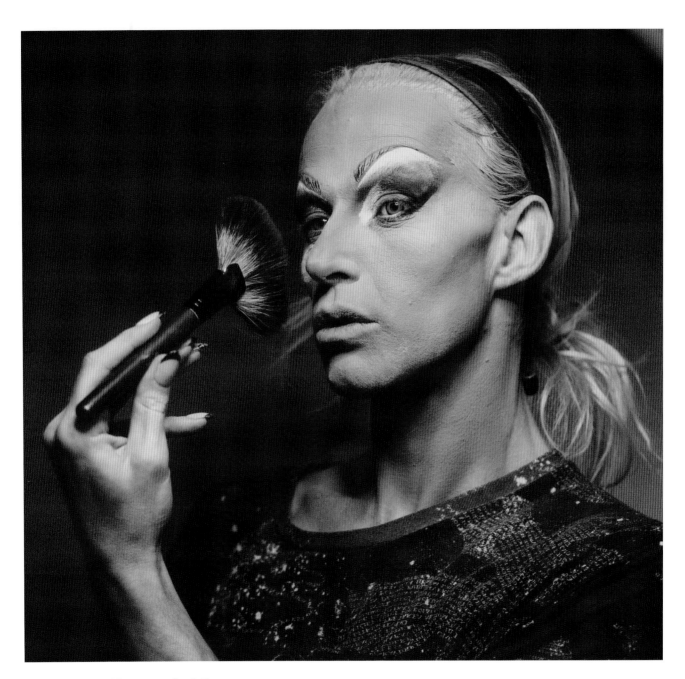

Here I am brushing away the fall.

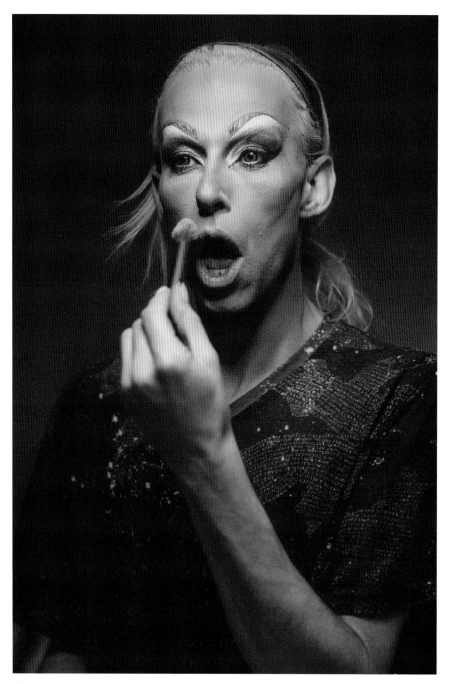

To get into full drag it takes approximately two hours. Sometimes I can be getting ready for a gig when I hear a pony get loose, and there's me, full face of make-up and in high heels, running across a field to catch them.

It took some time to figure out Boo's face, how to do her lips and get the correct foundation colour, using inspiration from YouTube videos and a lot of trial and error.

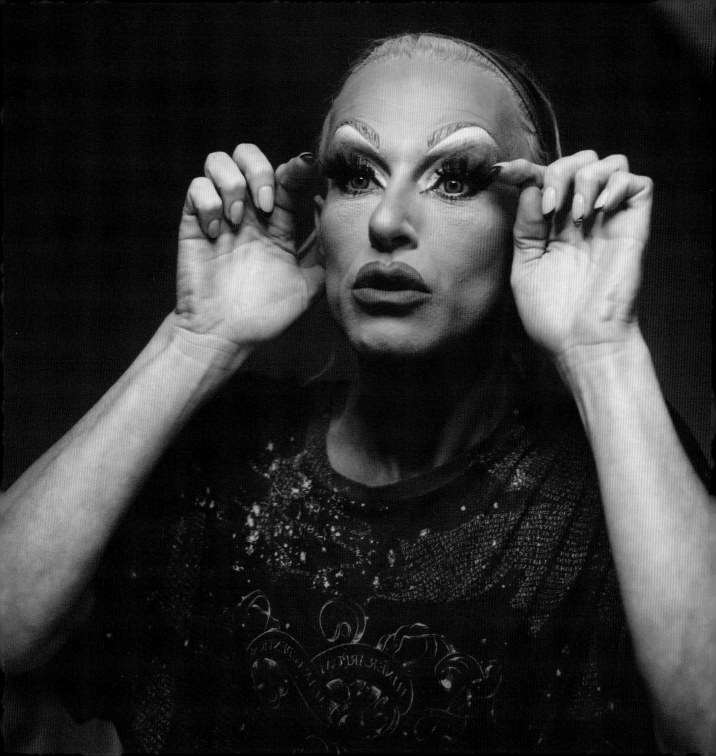

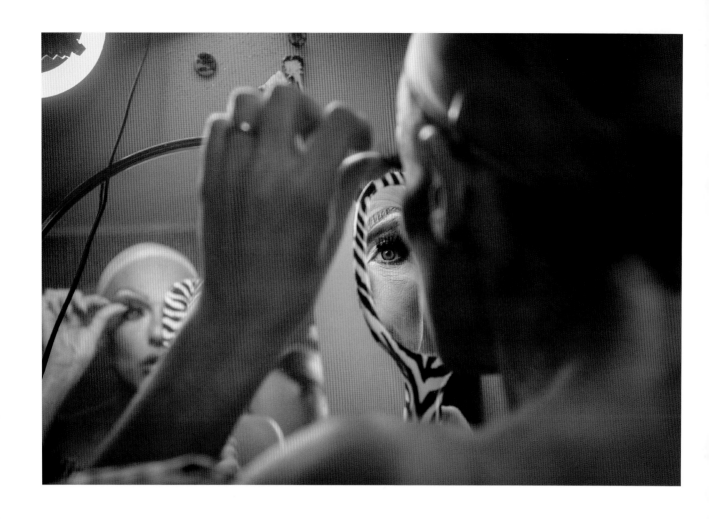

The more time goes by, the better
I get at perfecting my craft.

After a rocky start with my dad, who struggled to accept my sexuality in the beginning, he later became my biggest supporter. But it breaks my heart that he never got to meet my alter-ego Boo before he passed away in 2009.

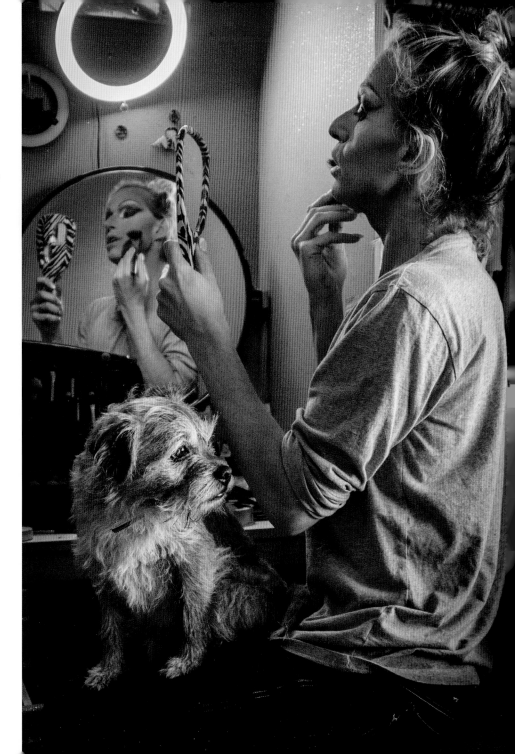

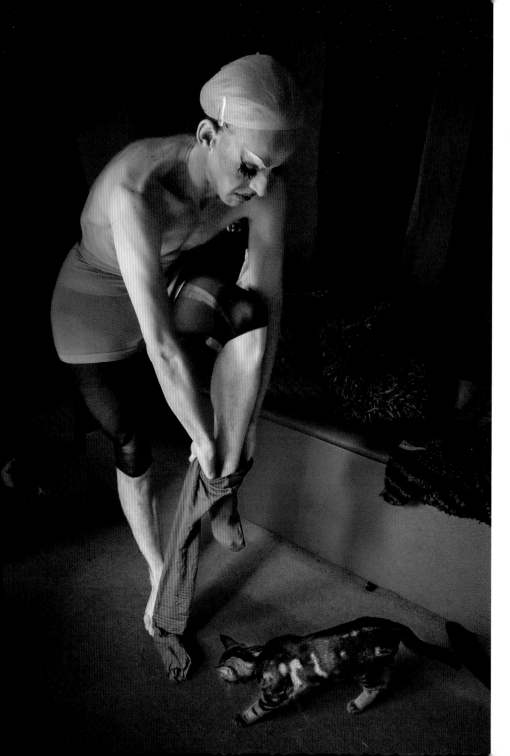

I made the hip pads myself to achieve my feminine shape, using a couch cushion that hasn't been washed for seven years.

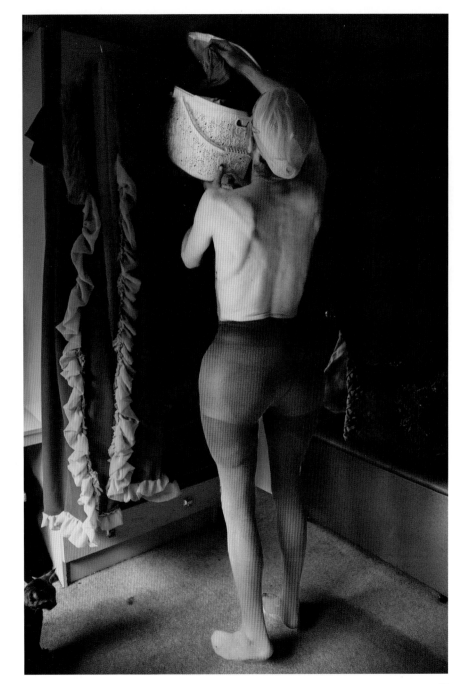

When asked by
members of
the public how I
achieve my shape,
I tell them, 'It's all
secrets and lies.'

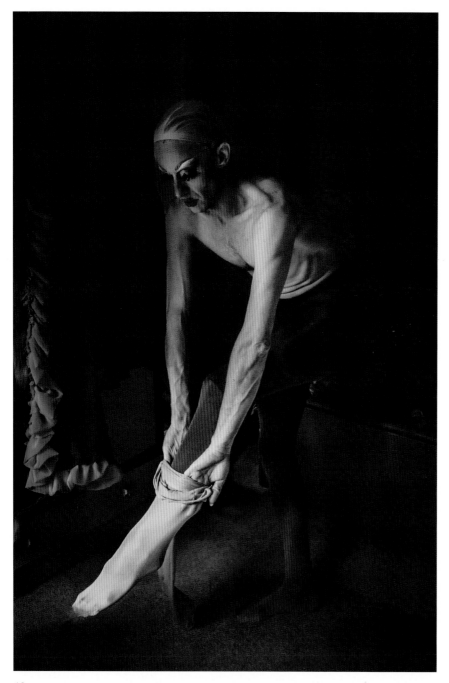

This is Boo getting ready, in front of me, for the first time. It was a real eye-opener to see the process and all that is involved in achieving the look.

Boo and I have a lot in common – photography and drag are both very visual art forms involving a lot of creativity. We're also on the same wavelength, we have been totally open with each other throughout this project. Of all the photos I've ever taken, this is among my favourites – I have a large framed print of it on my wall.

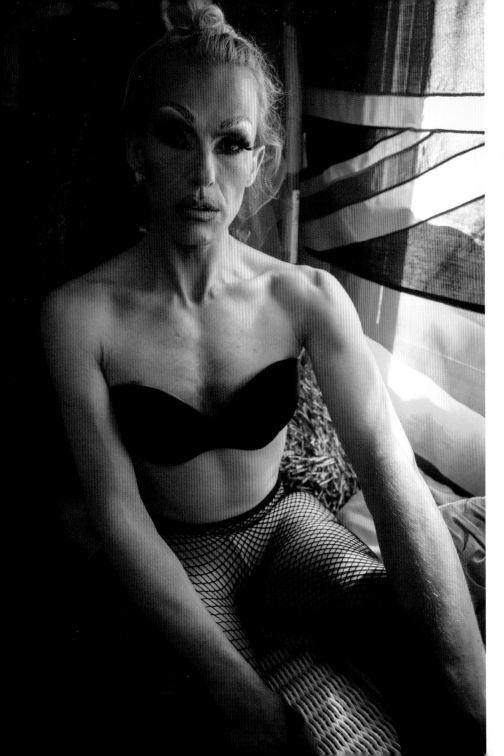

From the beginning of this
project, Boo has generously
allowed me to photograph
absolutely everything – even
the most intimate moments of
transforming into a drag artist.

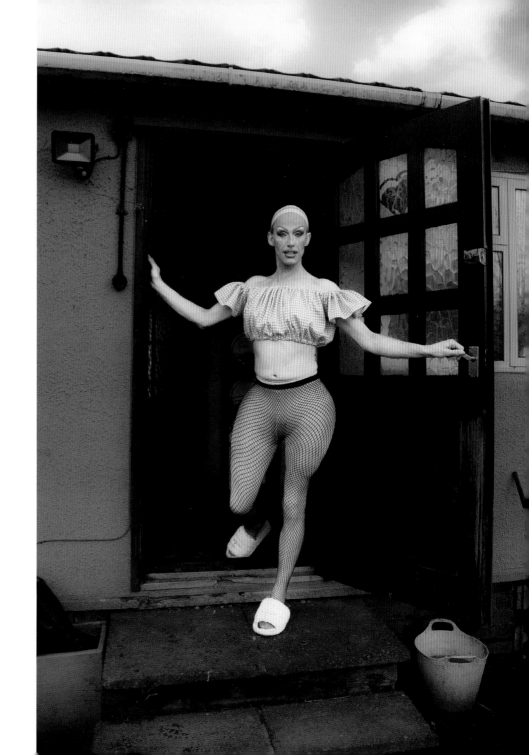

This is how Boo answered
the door to me when
I arrived to photograph
him with the cattle.

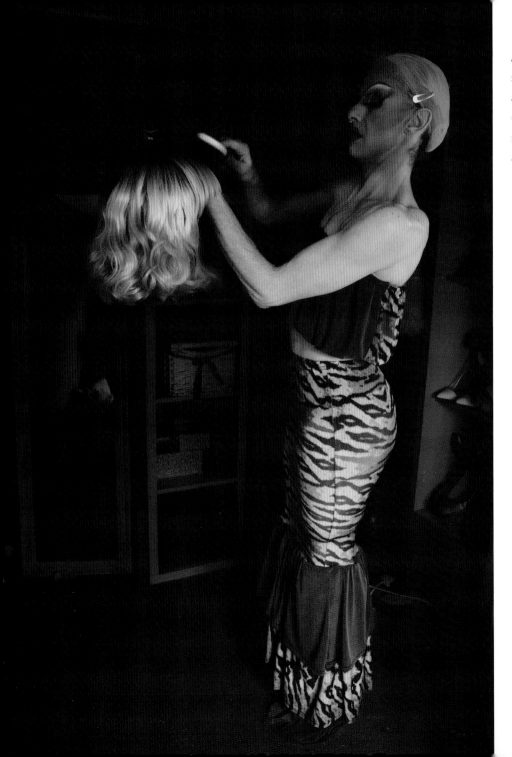

As a hairdresser, I cut and style all my own wigs to achieve the look I want, as opposed to buying them ready styled. To save money I wash and restyle the wigs I have regularly to achieve new looks.

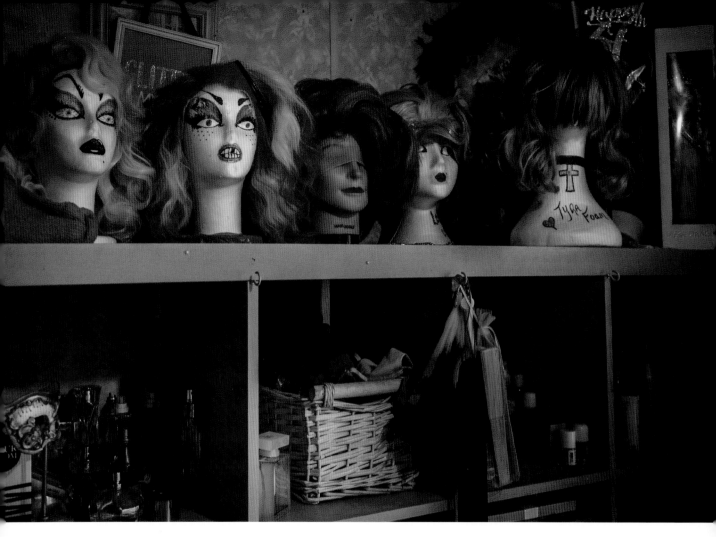

Some of the many wigs that have been worn and adapted for Boo's many looks.

Boo's dressing room is like a
voyage of discovery – I could
rummage around in there for days!

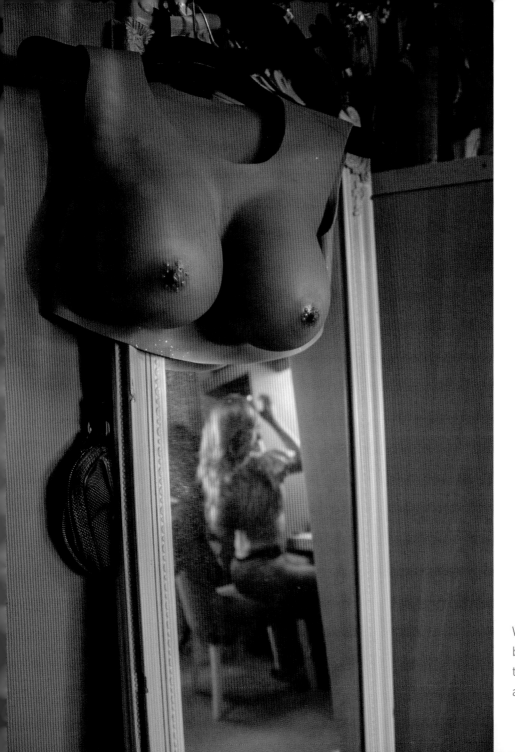

When I first saw this silicone
breast plate hanging from
the door I was obsessed and
asked Boo if I could borrow it.

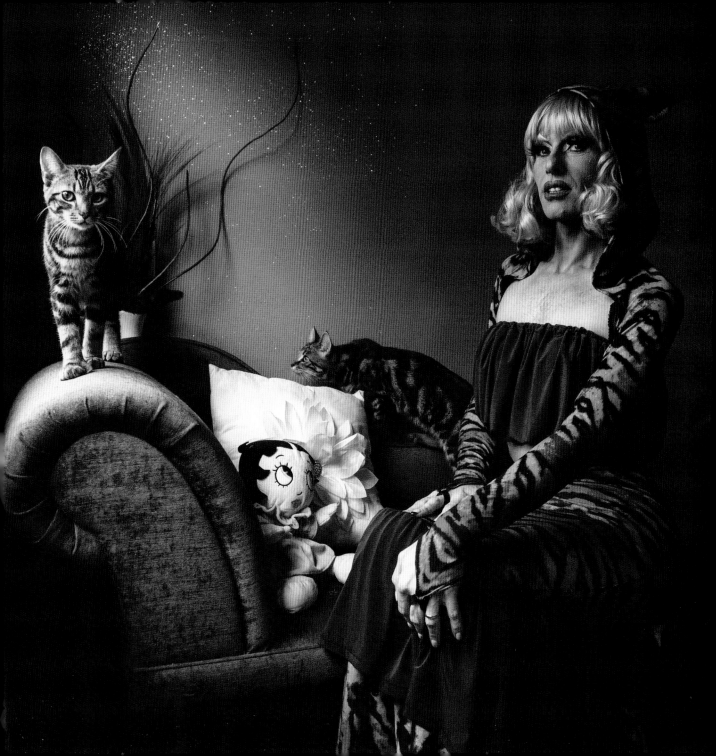

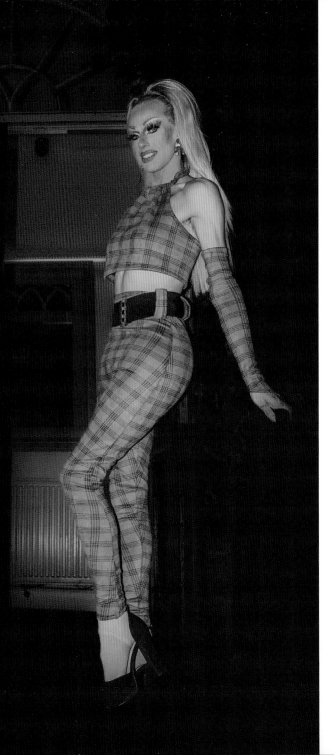

Muck by day and diamonds by night.

It was shocking for me to see numerous women drunkenly grabbing at Boo's genitalia ('to see what was there') while she worked on the door at an event.

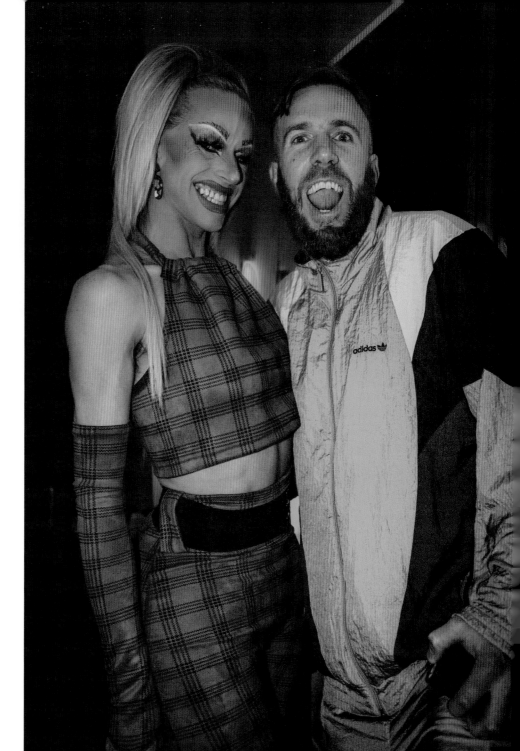

I will always cherish the people I've met and the opportunities they have given me. Here I am with DJ Max Galactic at a 90s Night in Hay.

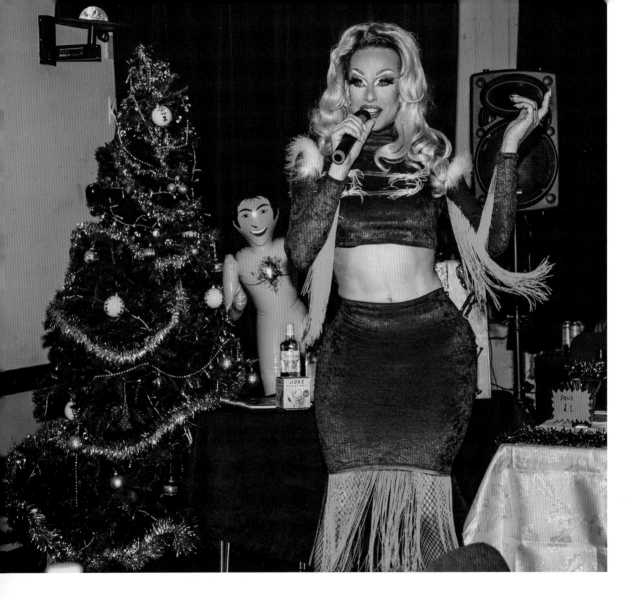

Boo organised a drag bingo
night in the local village hall for
Christmas 2022, which was a total
sellout. Half an hour before the
night began, Boo found his horse
Crunchy dead in the field. Although
he was utterly heartbroken, he
carried on with the night so as not
to disappoint the ticket holders.
A true pro.

The local community throwing themselves into the Christmas drag bingo night at the village hall.

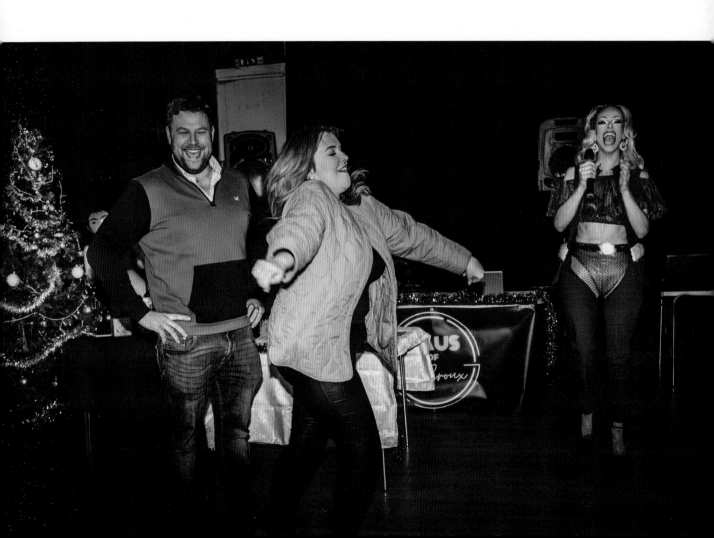

This was the very first photo I took
of Boo as she opened Hay Pride
2022, and from this moment the
most incredible and rewarding
relationship began between us.

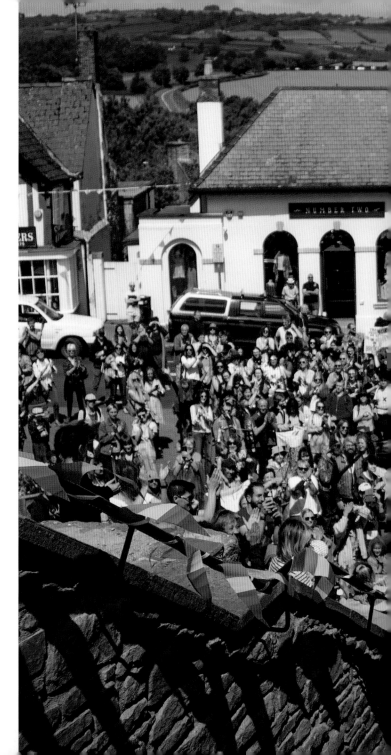

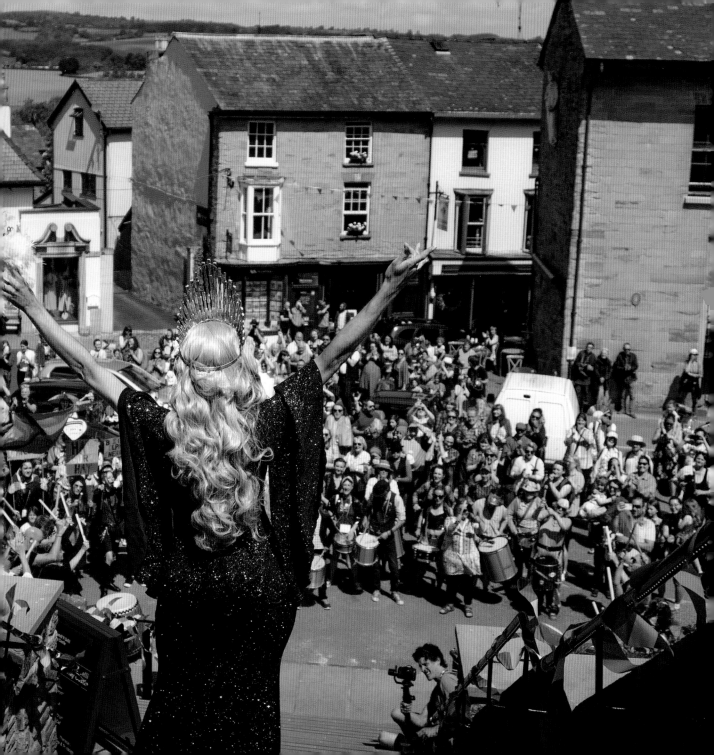

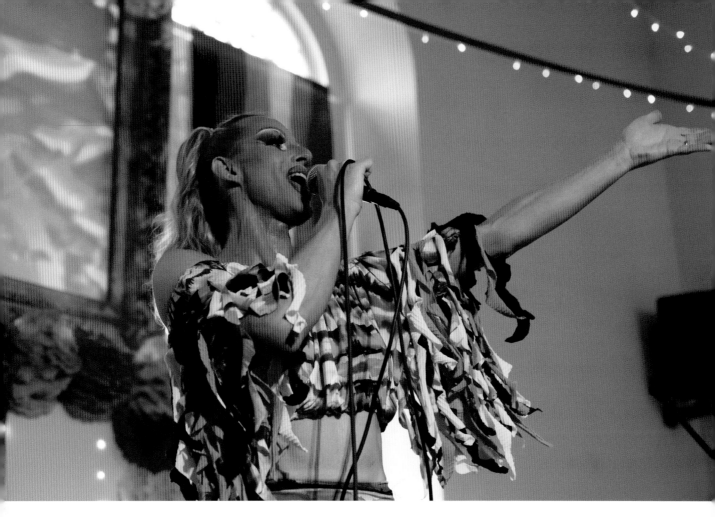

Drag and photography both have a
strong element of performance –
I use lots of different techniques to
put people at ease so that I can get
the best pictures out of them.

Why Boo? Well, even if you don't like what I do, you're still screaming my name!

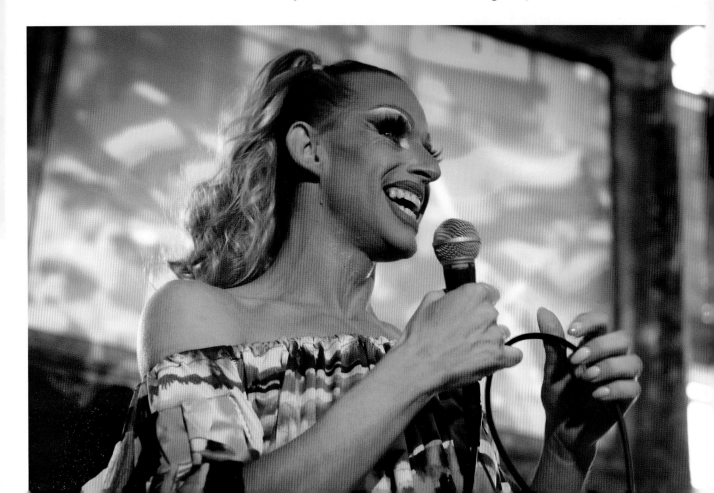

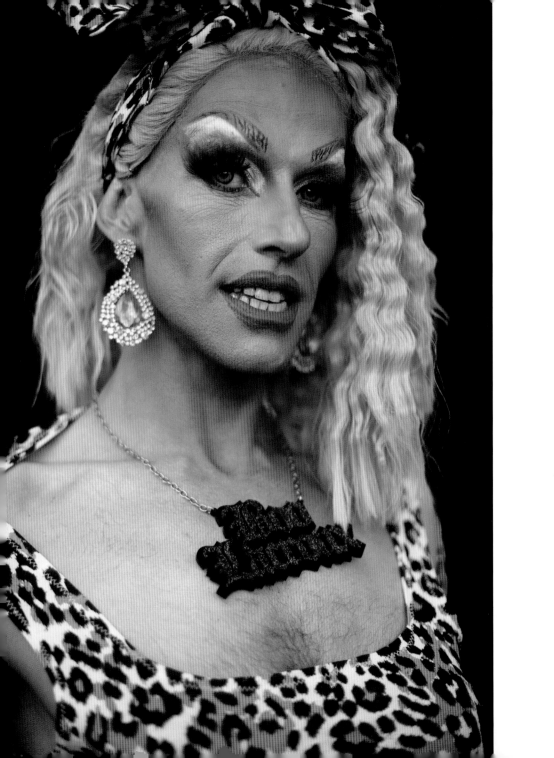

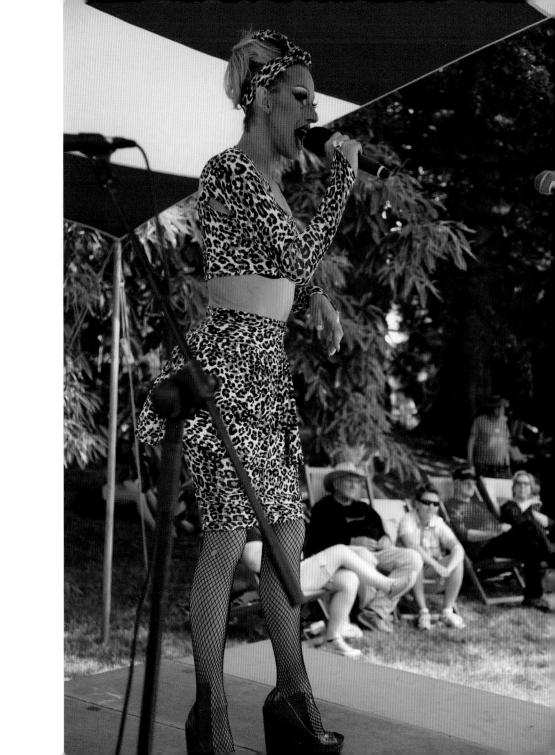

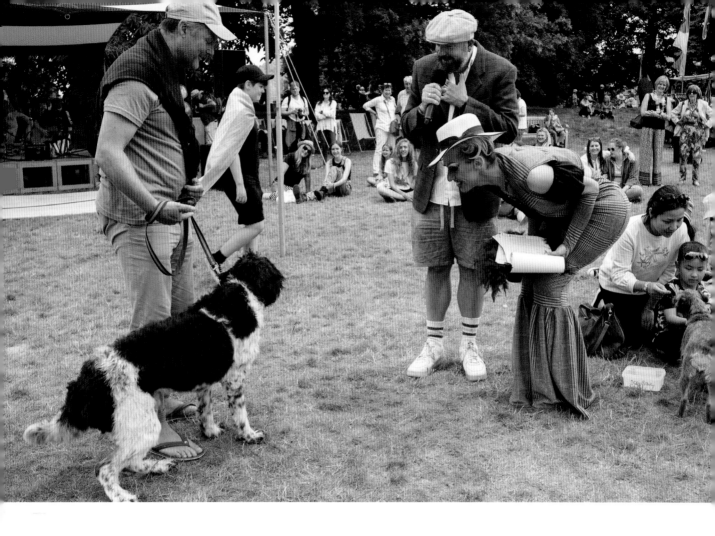

I'm so proud to represent and advocate for the rural LGBTQ+ community.

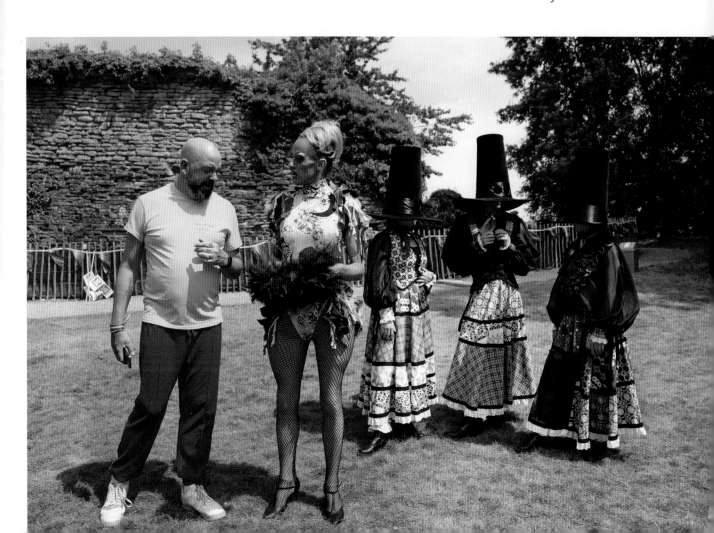

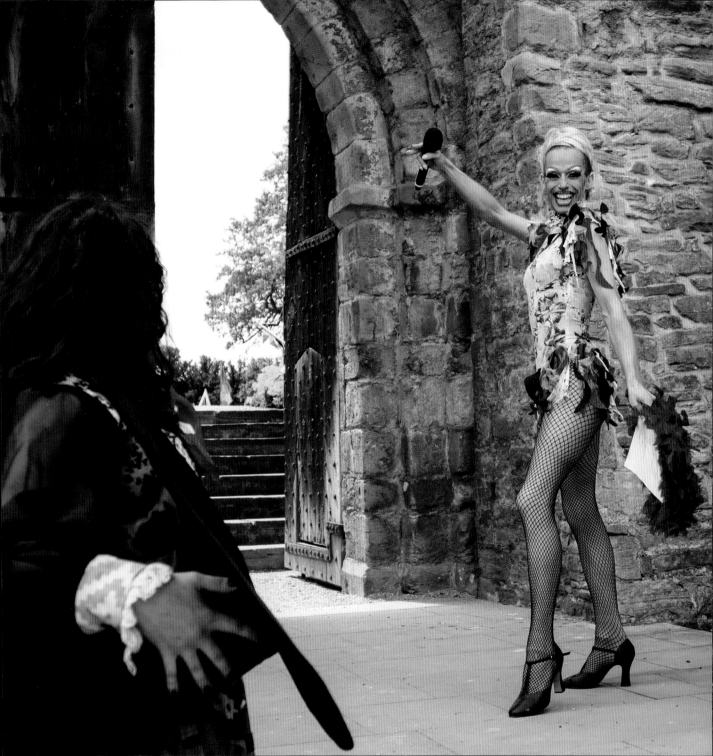

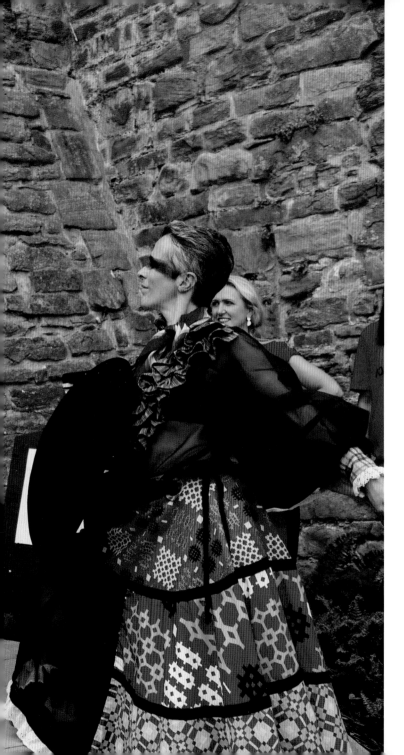

'If opportunity doesn't knock, build a door.' This mantra by Milton Berle inspires me to keep doing more with my drag.

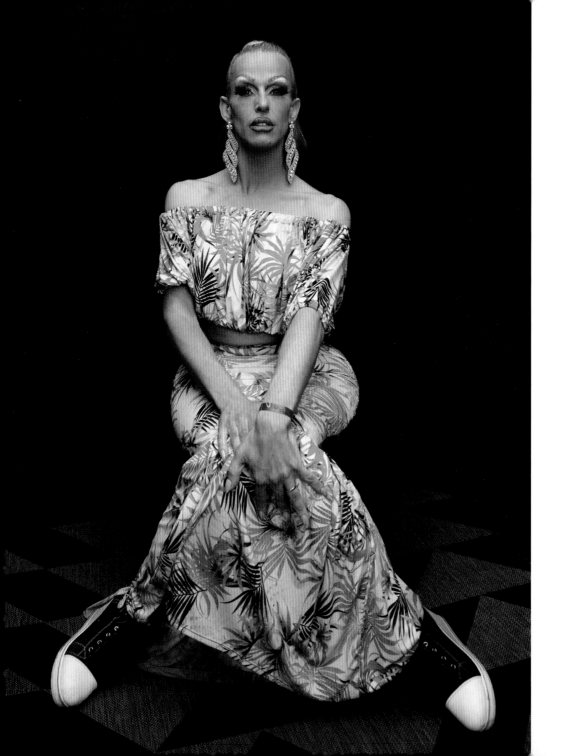

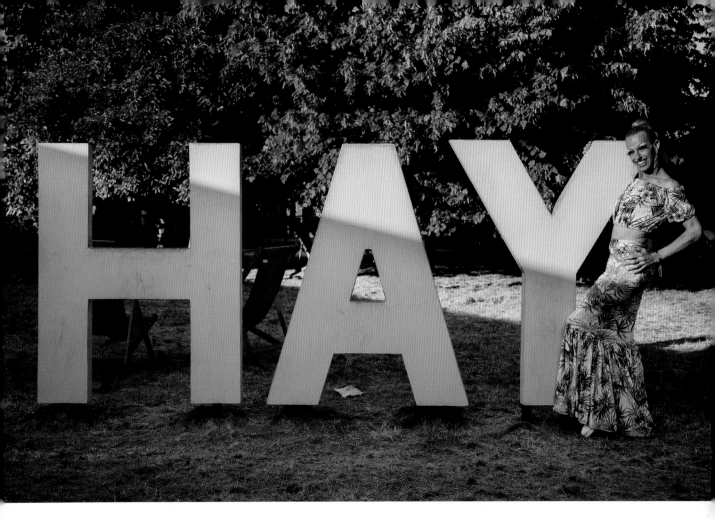

Boo hosted the closing party for Hay Festival in 2023, with DJ Max Galactic.

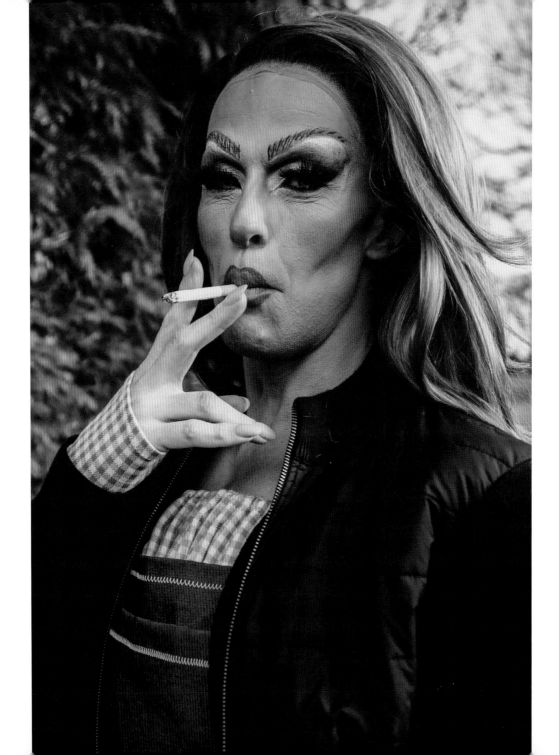

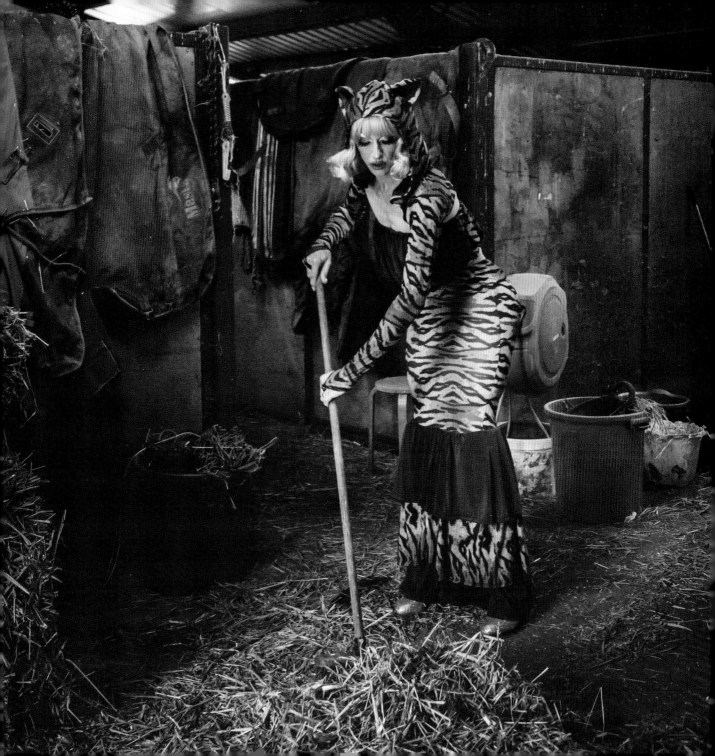

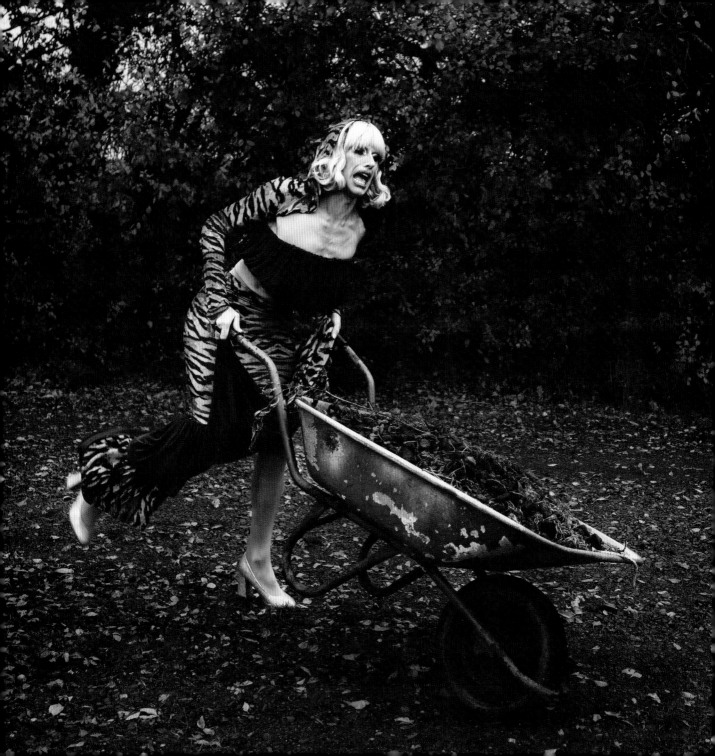

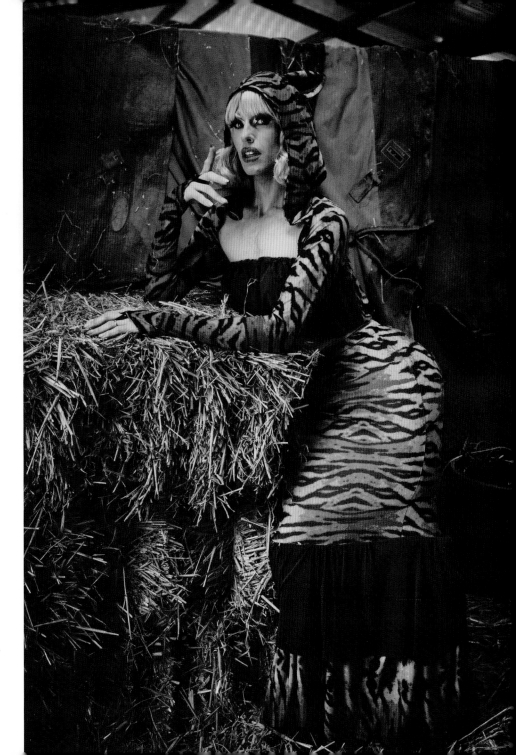

Often there are emergencies on the farm which have to be dealt with, whether as farmer or drag queen – the animals come first.

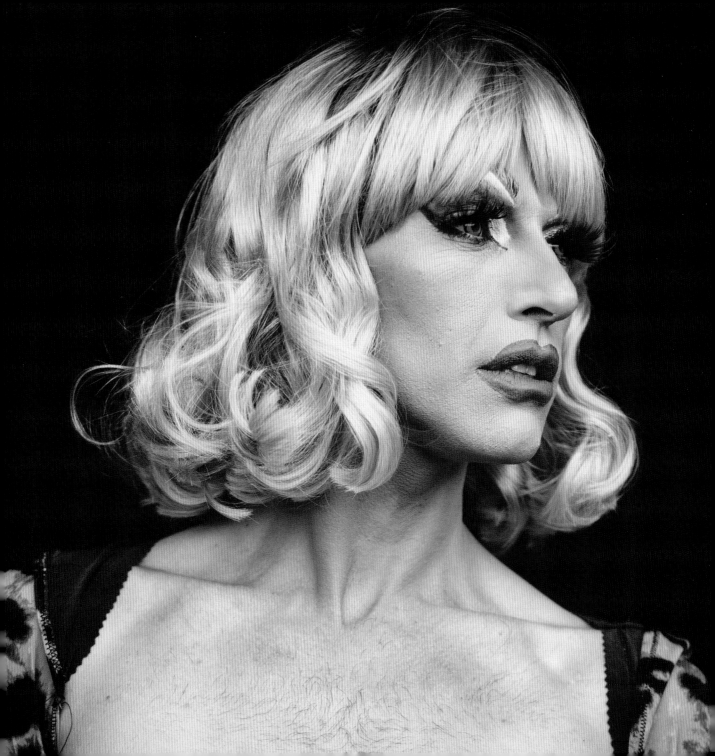

'When a gay man has WAY too much fashion sense for one gender he is a drag queen.' Noxema Jackson in the film *To Wong Foo, Thanks for Everything! Julie Newmar*.

This film has always had an influence on me ever since it came out in 1995 when I was ten. I used to secretly rent it from the video shop on a Friday night and return it on a Sunday, every single week!

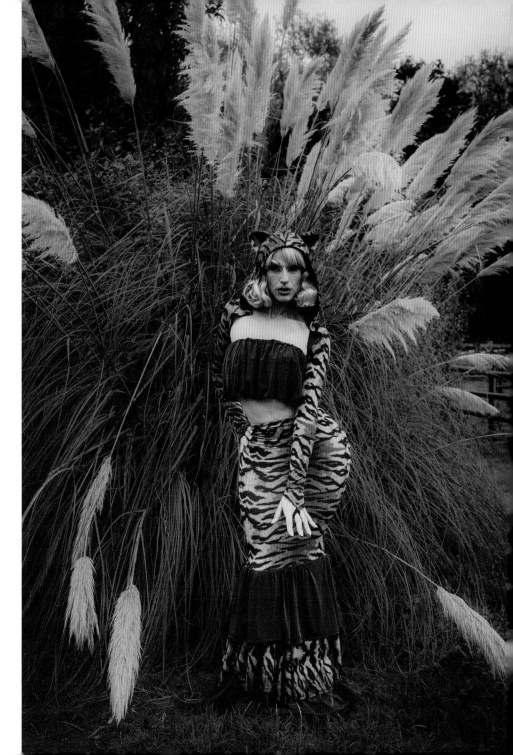

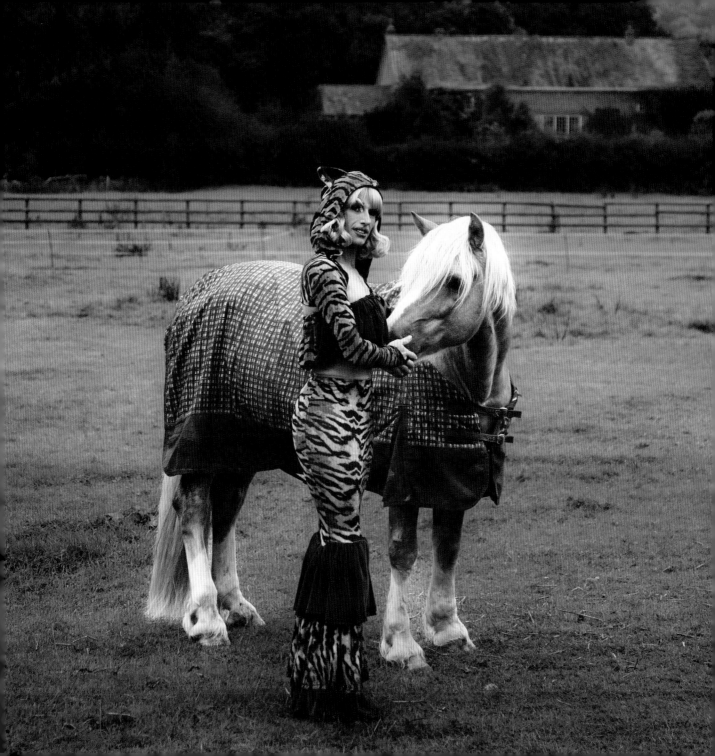

This is Crunchy, who passed away over Christmas 2022. Having depression from grief can be a real struggle, but having a love and focus of drag helps me navigate through it.

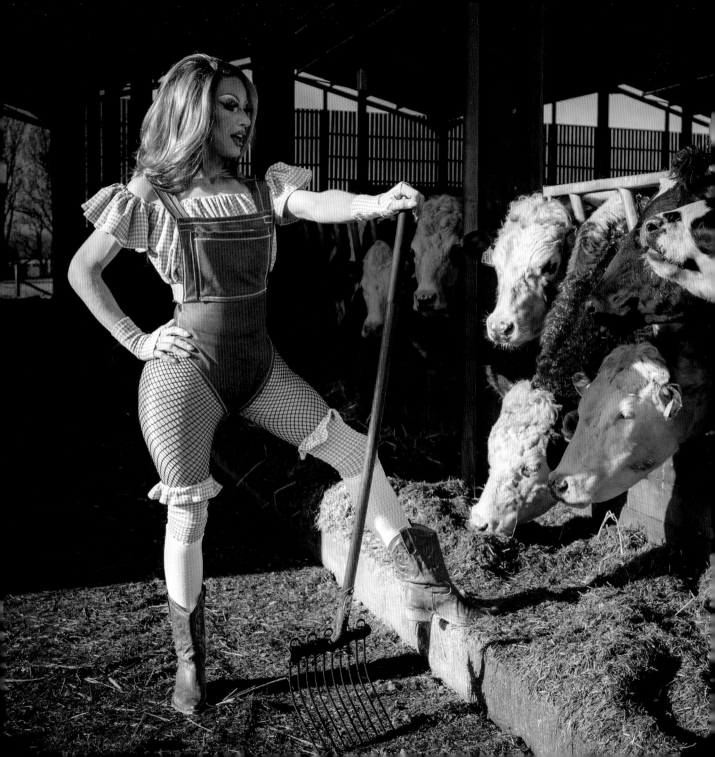

At the beginning of my drag journey, I was worried that the animals wouldn't recognise me, but to my surprise they accepted that it was me and always knew who I was.

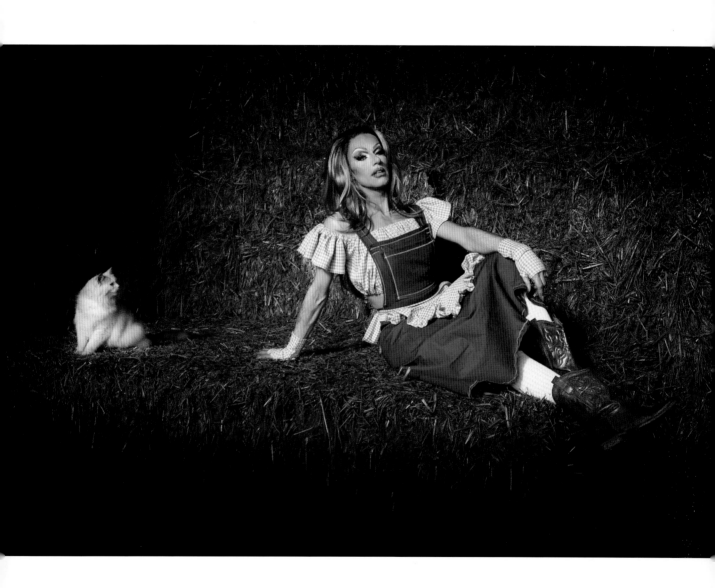

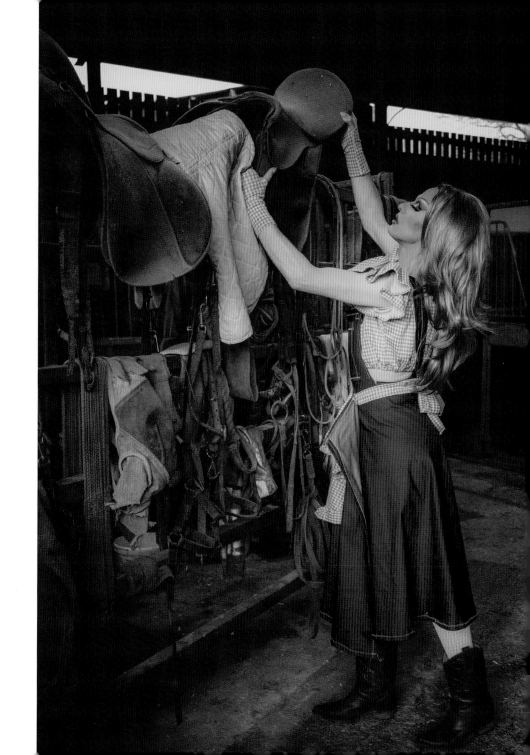

Hereford's very own pony
princess.

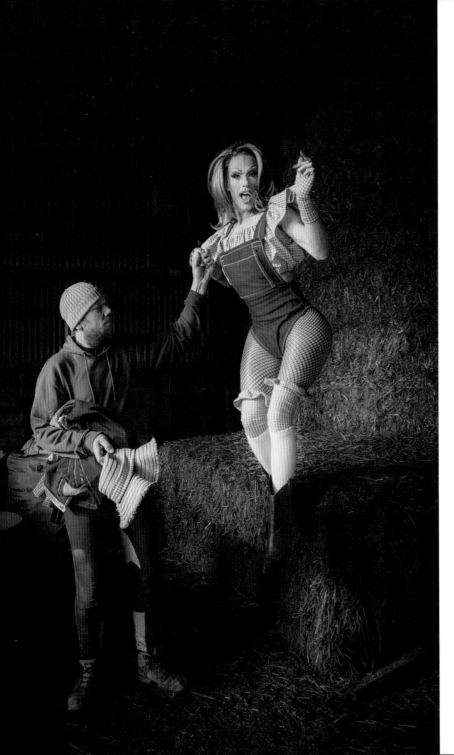

It was a year before I told my husband Paul I was practising drag make-up, and he's been so supportive of my love of drag ever since.

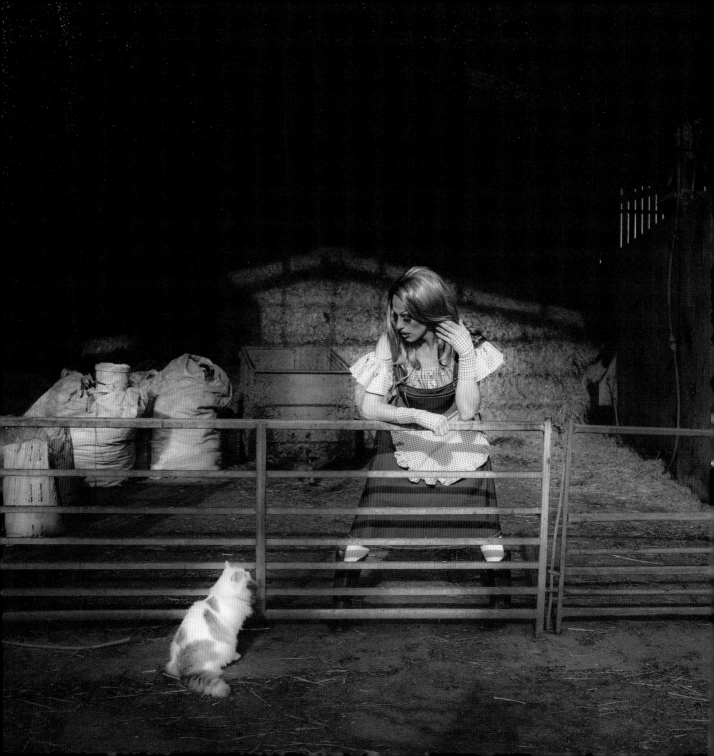

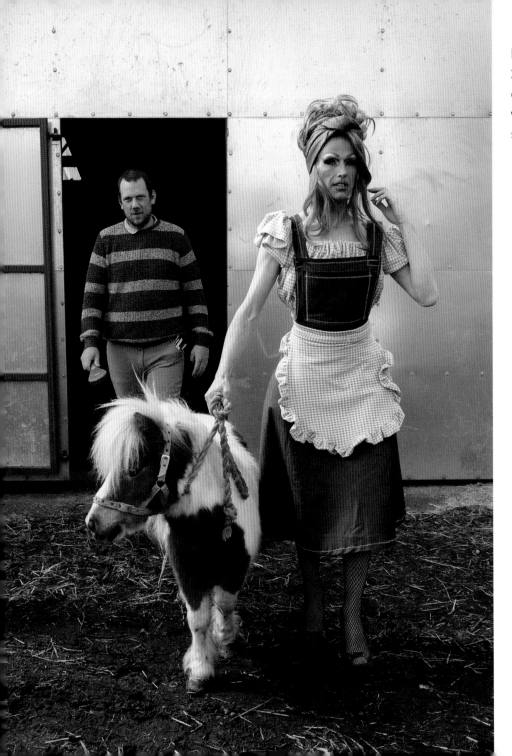

Paul and I got married in 2010, and even though life changed dramatically in 2016 when Boo was born, Paul's support has been unwavering.

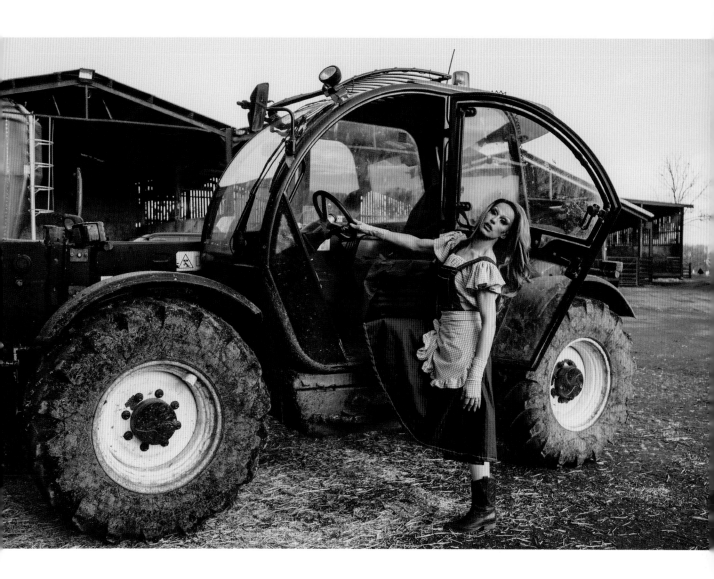

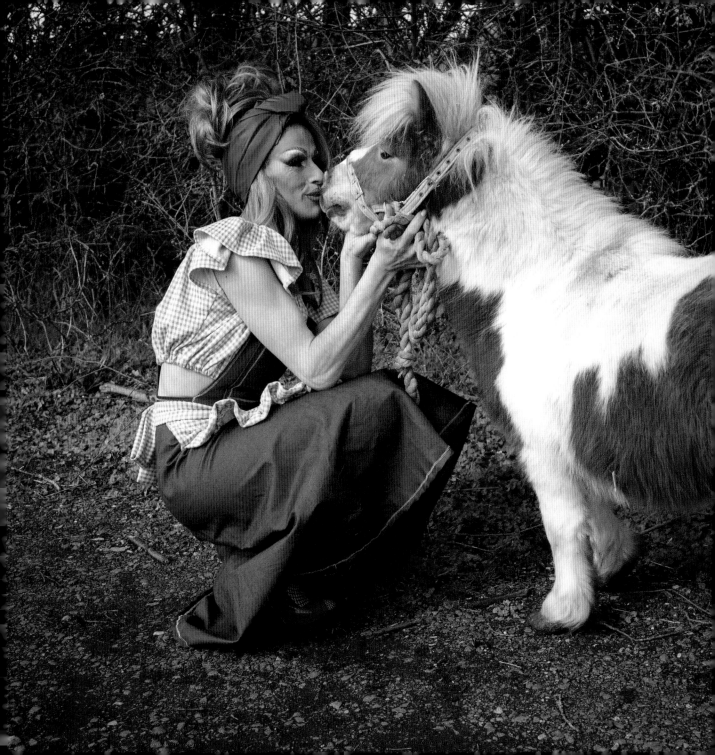

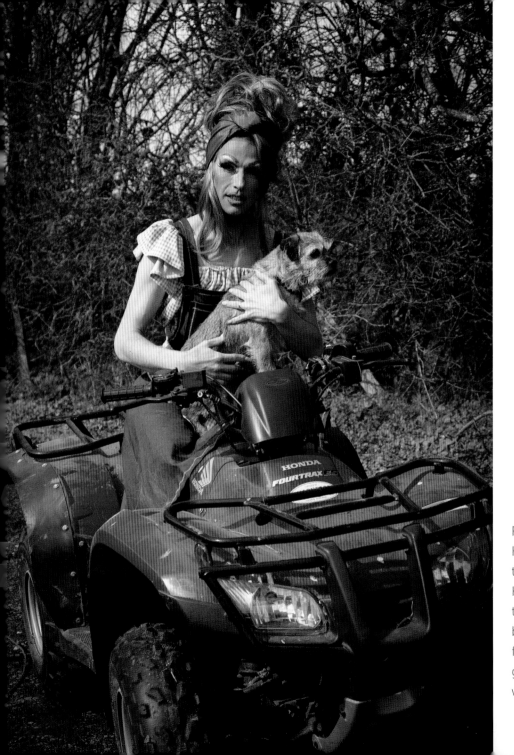

Right: When Boo and I visited
Hay and Brecon Farmers,
the response was incredible.
Here Boo sits with Kevin in
the shed, having a cup of tea,
before buying her chicken
feed. The support that Boo
gets in this rural area is really
wonderful to see.

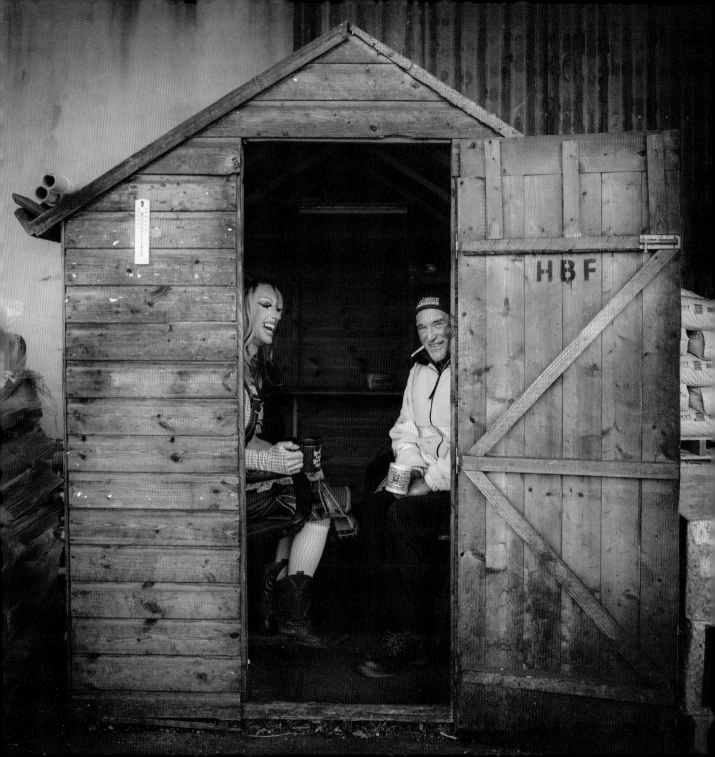

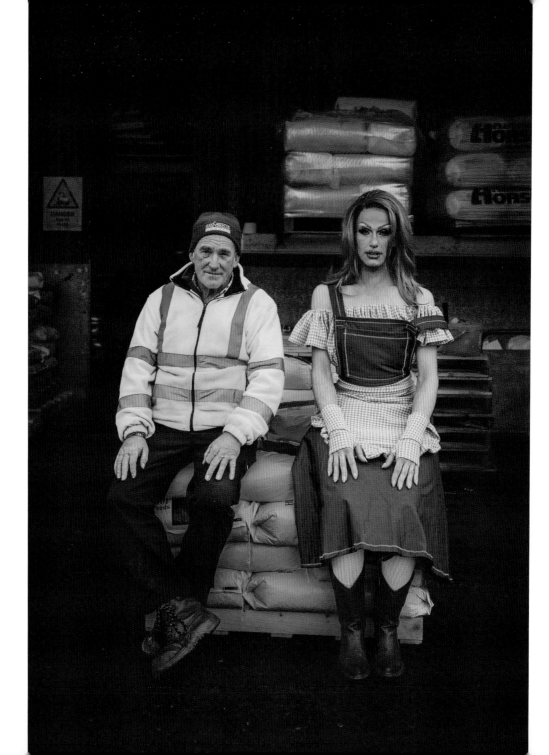

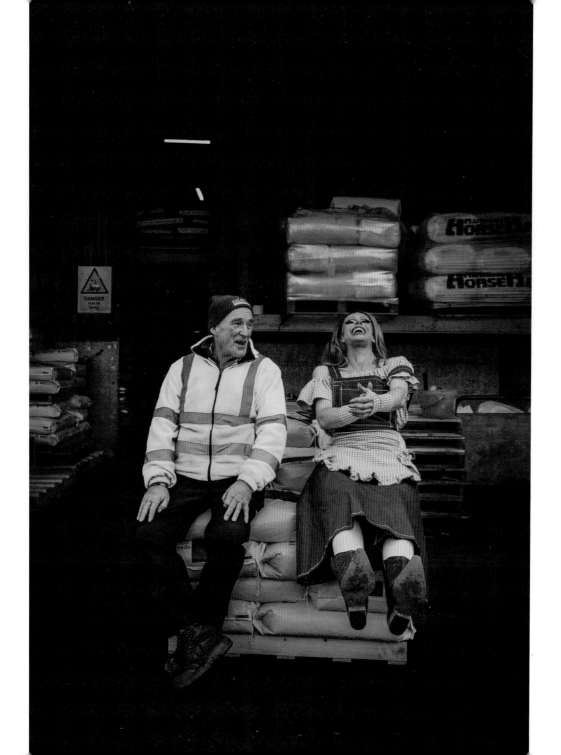

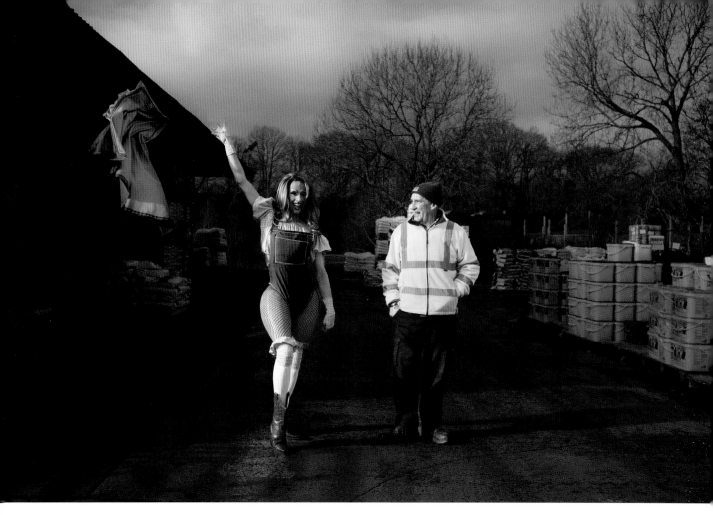

It saddens me that we do still have some way to go in people's acceptance of anything that is not white and straight, and I have heard awful, small-minded comments, but thankfully this is not the norm.

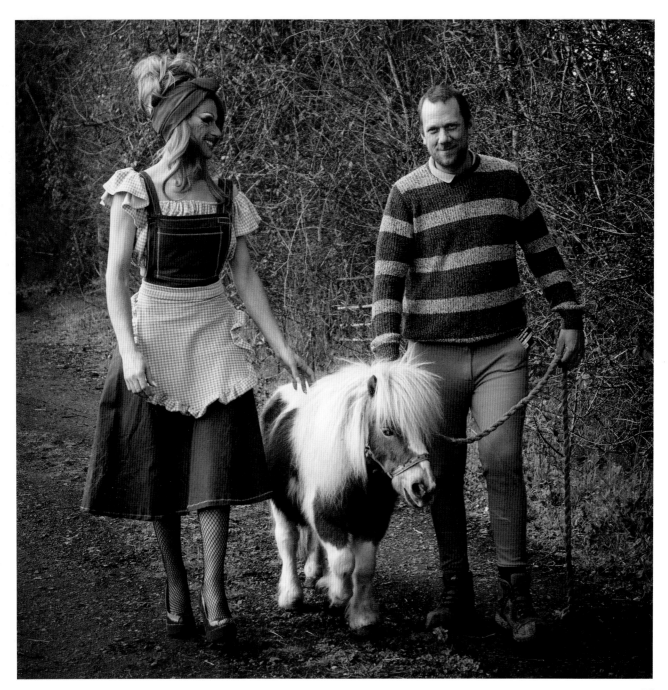

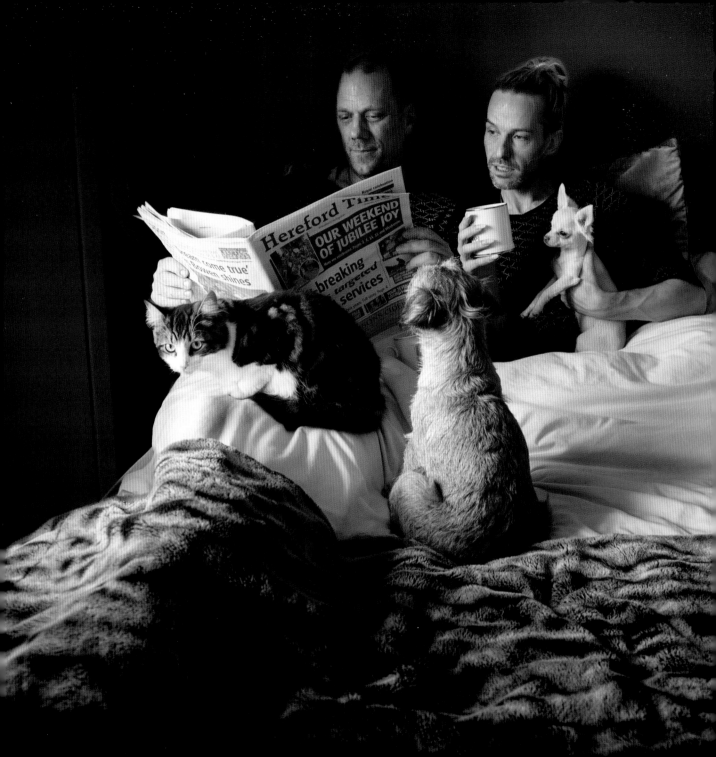

Sunday morning in the Boo
household.

Doing this project
with Billie has
been so exciting,
rewarding and
in some ways
vulnerable, hopefully
showing others it's
OK to be who you
want to be in a rural
community.

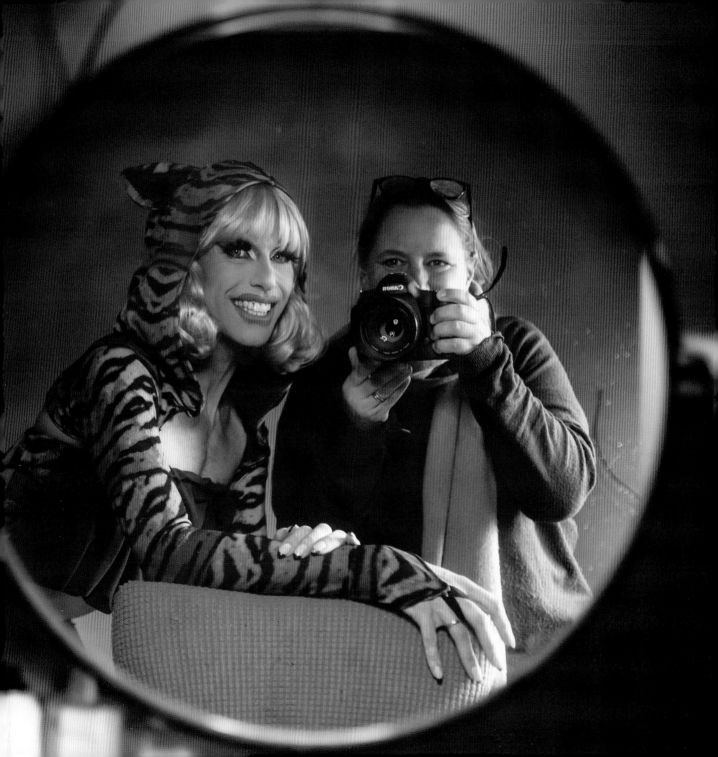